THE KNITTER'S COMPANION

expanded and updated!

VICKI SQUARE

INTERWEAVE
interweave.com

Design, Paulette Livers
Illustration, Vicki Square
Photography, Joe Coca
Video Studio Manager, Garrett Evans
Video Producer, Rachel Link

Photography © 2006, Interweave Press LLC
Illustration © 1996, 2006, Vicki Square
Video © 2010 Interweave Press LLC

Interweave Press LLC
201 East Fourth Street
Loveland, Colorado 80537 USA
interweave.com

Printed in China by Asia Pacific Offset

Library of Congress Cataloging-in-Publication Data
Square, Vicki, 1954-
 The knitter's companion : expanded and updated / Vicki Square, author.— [Rev. ed.]
 p. cm.
 Rev. ed. of: The knitter's companion. 1996.
 Includes index.
 ISBN 978-1-59668-314-3 (hardback with DVD)
 ISBN 978-1-59668-001-2 (hardback)
 1. Knitting. 2. Sweaters. I. Square, Vicki, 1954-. Knitter's companion. II. Title.
 TT825.S714 2006
 746.43'2—dc22
 2006001440

10 9 8 7 6 5 4 3 2 1

CONTENTS

INTRODUCTION

For me, knitting is an adventure in a wonderland. I love the twists and turns and stops along the way that give me a chance to experience the delights of discovery in the knitting world. I find deep satisfaction in working with the rich traditions that knitters have developed over the centuries and a thrill of new creative energy when I step completely outside the box. And throughout it all, I get profound pleasure in being part of the instant connectedness knitters have with one another everywhere.

In the current renaissance in knitting interest, there is a veritable banquet of new yarns and tools to choose from. Yet in this ever-changing landscape of innovative colors, textures, and ideas there remains the constant imperative for a solid and stable foundation of knowledge. Learning to knit is a process of perfecting and challenging. Do not expect to be an expert in a few short lessons, but savor the process of learning, and find joy in the sharing.

This little book is meant to be your companion as you forge your knitting skills. Carry it with you, keeping the wealth of basic information at your fingertips, instead of home on a shelf. As always, it is full of the "most used," and "best loved" techniques for knitting, shaping, and finishing. From understanding yarn and its care, choosing gauge, style, and fit, through sorting out and understanding the various methods for casting on, increasing, decreasing, binding off, seaming, and adding details, this book will serve as a trusted teacher and companion.

With this new version, I've expanded the information to include how to read a pattern and more ways to cast on, bind off, and increase stitches. I've also added details—tassels, fringe, knitting with beads, working cables, and more—and tips sprinkled throughout to help you achieve the best result possible. My new drawings clarify the step-by-step techniques in living color and photos illustrate the finished look.

My prayer is that you will enjoy this revision of The Knitter's Companion, and find it will enhance your growing expertise as a knitter.

IN PREPARATION

Supplies and Notions

Knitting bag, or bags!

Knitting needles—Ideally you'll have circular, single- and double-pointed straight needles in every size. Most knitters acquire needles as needed.

Stitch gauge

Needle gauge

Stitch markers

Stitch holders

Point protectors

Cable needles—Small, medium, and large to use with fine to bulky projects.

Crochet hooks—Various sizes for correcting mistakes and working edges.

Rust-free pins—2" (5 cm) long with colored heads to pin pieces together for seaming.

Large-eye tapestry needle

Scissors

Tape measure

Zippered bags in various sizes for storing all your knitting notions.

Notebook

Sticky notes—Good for quick notations and marking your place in a pattern.

Magnet board—Indispensable for tracking each row when following a complex pattern or following a graph.

Nail file—Handy for honing off a rough fingernail that catches yarn.

Yarn Structure

All yarn is made of spun fiber, whether the fibers are natural such as wool, cotton, or silk, or synthetic such as acrylic or microfiber, or a blend of the two. The fibers are spun to twist them together into a continuous, strong yarn. A single strand of spun fiber is called a singles. Plying two, three, or four singles together makes two-ply, three-ply, or four-ply yarn, and so on. But the number of plies does not determine the weight of the yarn—there are single-strand bulky yarns, as well as four-ply fingering yarns.

Twist Direction

Twisted yarn spirals in either the "Z" direction in which the twists run upward to the right, which is considered standard, or the "S" direction in which the twists run upward to the left.

Z

S

Yarn Textures

In evenly textured yarns, the strands all have the same thickness. Novelty yarns combine strands of different thicknesses or textures.

Spiral A thin yarn spun around a thick yarn.

Spiral

Slub A single strand that varies from thick to thin plied with either a smooth or slubbed strand.

Slub

Nub Two strands plied so that one overwinds at certain intervals producing bumps.

Nub

Bouclé Two strands plied at different tensions to produce loops that are held in place with a thin binder thread.

Bouclé

Chenille Two thin threads tightly plied around a short, velvety pile.

Chenille

Eyelash Thin threads tightly plied with loose strands up to 3" (7.5 cm) long that hang out at regular intervals.

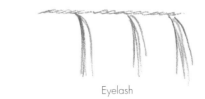
Eyelash

Yarn Sizes

The Craft Yarn Council of America (CYCA) gives guidelines for six standard categories based on yarn thickness. Although I have listed the common uses for each yarn type, don't let this stifle your imagination. Adopt a "no-rules" attitude to create the look you want. Many beautiful yarns knit to a bulky gauge, but do not look bulky as a single strand. For example, a beautiful airy, lacy shawl can be knitted with fingering-weight yarn on size 10½ (6.5 mm) needles. Take the lid off your creativity box, and merrily knit your way through gauge samples until you have just what you want!

Super Fine Sock, baby, or fingering-weight yarn is best suited for close-fitted clothing such as socks and gloves, as well as baby clothing. Use U.S. size 1 to 3 (2.25 to 3.25 mm) needles and work 27 to 32 stitches to 4" (10 cm).

Super fine

Fine Sportweight yarn is about twice as thick as fingering-weight, with an extremely wide variety of uses, from somewhat heavy socks to lightweight sweaters. Use U.S. size 3 to 5 (3.25 to 3.75 mm) needles and work about 23 to 26 stitches to 4" (10 cm).

Fine

Light DK (double knitting) and light worsted-weight yarn is slightly thicker than sportweight but slightly finer than typical American worsted. This yarn can be used for most projects that call for sport or worsted yarn. Use U.S. size 5 to 7 (3.75 to 4.5 mm) needles and work about 21 to 24 stitches to 4" (10 cm).

Light

Medium Worsted-weight yarn is useful for all types of projects, from garments to afghans to accessories. Use U.S. size 7 to 9 (4.5 to 5.5 mm) needles and work 16 to 20 stitches to 4" (10 cm).

Medium

Bulky Chunky, craft, or rug yarn is heavier than worsted and is useful for outdoor sweaters and accessories, and lightweight jackets. Use U.S. size 9 to 11 (5.5 to 8 mm) needles and work 12 to 15 stitches to 4" (10 cm).

Bulky

Super Bulky Bulky or roving is very thick and is a good choice for very heavy sweaters, coats, and afghans. Use U.S. size 11 (8 mm) and larger needles and work 6 to 11 stitches to 4" (10 cm).

Super bulky

Yarn Label Symbols

Needles and hooks

Manufacturer's suggested knitting needle size in U.S. and/or metric sizes.

Manufacturer's suggested crochet hook in U.S. and/or metric sizes.

Gauge or tension

Manufacturer's suggested gauge and needle size. This will usually read so many stitches and so many rows equal 4" × 4" or 10 cm × 10 cm.

Washing

Note: Tub and temperature diagrams may not always mean machine washable.

Do not wash by hand or machine.

Handwashing

Handwash in lukewarm water only.

Handwash in warm water temperature indicated.

Machine washing

Machine wash in water at temperature indicated, cool rinse, short spin.

Machine wash in warm water at temperature indicated.

Bleaching

Do not bleach.

Chlorine bleach permitted.

Pressing

 Do not press.

 Press with a cool iron.

 Press with a warm iron.

 Press with a hot iron.

Dry cleaning

Note: Check with your dry cleaner as to which solvents are used before having your garment cleaned.

 Do not dry clean.

 Dry clean with fluorocarbon or petroleum-based solvents only.

 Dry clean with perchlorethylene or fluorocarbon or petroleum-based solvents only.

 May be dry cleaned with all solvents.

Formula for Interchanging Yarns

Yarns of similar weight and similar texture can generally be interchanged effectively. But there can be a large range in length between balls of two different yarns of the same weight, depending on the fiber type, number of plies, and tightness of the twist.

The number of balls required times the number of yards (or meters) per ball = total number of yards (or meters) needed.

The total number of yards (or meters) needed divided by the number of yards (or meters) in one ball of substitute yarn = number of balls needed of substituted yarn.

For example, if 12 balls of the required yarn have 145 yards (133 meters) each, then the total number of yards (meters) you'll need is

12 balls × 145 yards = 1740 total yards.

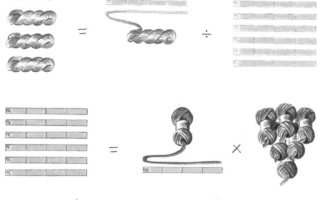

If you want to substitute a yarn that has 163 yards (149 meters) per ball, then you'll need

1740 total yards ÷ 163 = 10.67 balls.

Because you must buy full balls of yarn (and because it's always a good idea to have a little extra yarn) you'll want to buy 11 balls of the substitute yarn.

Yardage Estimates for Sweaters in Standard Yarn Weights

The following guidelines are for the amounts of yarn needed for a basic pullover or cardigan in a variety of sizes and yarn sizes (see Yarn sizes, page 8). These estimates are for smooth yarns and plain or lightly textured knitting. Keep in mind that heavily textured patterns such as all-over cables or oversized looks can easily require additional yarn (400–600 yards; 375–550 meters). When knitting with two or more colors, the total yardage will be greater to account for the yarns being carried across the back of the work. Estimate generously, and if you have leftovers . . . well, they're a designer's best friend!

BABIES 12–18 MONTHS
(for a pullover or cardigan)
fingering weight
 600–700 yards (550–650 meters)

TODDLERS 2–6 YEARS
(for a pullover or cardigan)
sportweight
 800–1000 yards (750–950 meters)
worsted weight
 600–800 yards (550–750 meters)
bulky yarn
 550–650 yards (500–600 meters)

CHILDREN 6–12 YEARS
(for a pullover or cardigan)
sportweight
 1000–1500 yards (950–1400 meters)
worsted weight
 900–1200 yards (850–1100 meters)
bulky yarn
 700–1000 yards (650–950 meters)

MISSES SIZES 32–40
For a regular, comfortable-ease pullover;
add 5% for a cardigan

fingering weight
 1500–1700 yards (1400–1600 meters)
sportweight
 1400–1600 yards (1300–1500 meters)
worsted weight
 1100–1400 yards (1000–1300 meters)
bulky yarn
 1000 yards (950 meters)

For a longer, loosely fitting, or oversized pullover;
add 5% for a cardigan

sportweight
 1500–1900 yards (1400–1750 meters)
worsted weight
 1300–1500 yards (1200–1400 meters)
bulky yarn
 900–1200 yards (850–1100 meters)

MEN SIZES 36–48
For a regular, comfortable-ease pullover;
add 5% for a cardigan

sportweight
 1700–2100 yards (1600–1950 meters)
worsted weight
 1500–1700 yards (1400–1600 meters)
bulky yarn
 1300–1500 yards (1200–1400 meters)

For a longer, loosely fitting, or oversized pullover;
add 5% for a cardigan

sportweight
 2000–2400 yards (1850–2200 meters)
worsted weight
 1800–2000 yards (1650–1850 meters)
bulky yarn
 1500–1700 yards (1400–1550 meters)

Taking Body Measurements

Accurate measurements will help you determine the size garment to knit. But keep in mind that you'll want to add some ease (see page 22 for suggested amounts). Some of these measurements are difficult to take by yourself—ask a friend to help you. If you have a sweater that fits just the way you want, you're in luck. Simply measure the sweater and knit yours to match.

Bust/chest (a). Measure around the fullest part. Make sure the tape measure doesn't slip down in the back.

Waist (b). Measure the smallest part where a belt would be worn.

Hip (c). Measure the fullest part, generally 9–10" (23–25.5 cm) below the waist. Make sure that the tape measure doesn't slip down in the back.

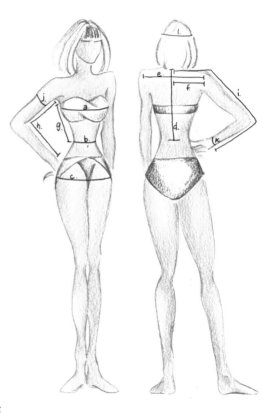

Back length (d). Measure from the prominent neck bone to the waist. It helps to tie a piece of yarn around the waist for accuracy—a common mistake is to measure too far into the small of the back.

Back width (e). Measure across the back from one shoulder bone to the other. (This is slightly different from taking a back width for sewing.)

One shoulder (f). Measure from the center back neck bone to the edge of the shoulder bone.

Waist to underarm (g). Tie a strand of yarn around the waist and measure from this marker to about 1" (2.5 cm) below the underarm crease. This measurement will help you determine where to begin the armhole shaping.

Wrist to underarm (h). Measure along the inside of arm from the wrist bone to about 1" (2.5 cm) below the armhole crease. This determines where to begin sleeve cap shaping for a set-in sleeve.

Center back neck to wrist (i). Holding the arm with the elbow slightly bent out to the side, measure from the center back neck bone, across the shoulder bone, and down across the elbow to the wrist bone. This measurement minus the "one shoulder" measurement will give the sleeve length.

Upper arm circumference (j). Measure the fullest part of the upper arm.

Wrist circumference (k). Measure around the wrist bone just above the hand.

Head circumference (l). Head circumference. This measurement is helpful for determining the size of a crew neck opening and, of course, for hats.

Body Measurement Tables

The "average" body measurements given here are based on the National Bureau of Standards. These measurements are especially helpful in judging sizes for garments knitted as gifts. Be sure to add the appropriate ease (see Sweater Ease Allowances, page 22) to these measurements to achieve a comfortable fit. For example, to size a sweater for a friend who wears a Misses size 12, consult the body measurement table for Misses sizes on page 19 and use the Sweater Ease Allowances chart on page 22 to determine how much ease to add to achieve the fit you want.

Babies (measurements are in inches with centimeters in parentheses)

Size	newborn	6 months	12 months
Chest	to 18 (45.5)	to 20 (51)	to 22 (56)
Waist	18 (45.5)	19 (48)	20 (51)
Hip	19 (48)	20 (51)	21 (53.5)
Back length	6⅛ (15.5)	6⅞ (17.5)	7½ (19)
Back width	7¼ (18.5)	7¾ (19.5)	8¼ (21)
One shoulder	2 (5)	2¼ (5.5)	2½ (6.5)
Waist to underarm	3 (7.5)	3⅜ (8.5)	3¾ (9.5)
Wrist to underarm	6 (15)	6½ (16.5)	7½ (19)
Armhole depth	3¼ (8)	3½ (9)	3¾ (9.5)
Upper arm circumference	6½ (16.5)	7 (18)	7¼ (18.5)
Wrist circumference	5 (12.5)	5⅛ (13)	5⅛ (13)
Head circumference	15 (38)	15 (38)	16 (40.5)

Children (measurements are in inches with centimeters in parentheses)

Size	2	4	6	8	10	12
Chest	21 (53.5)	23 (58.5)	25 (63.5)	27 (68.5)	28¾ (72.5)	30 (76)
Waist	20 (51)	21 (53.5)	22 (56)	23 (58.5)	24 (61)	25 (63.5)
Hip	22 (56)	24 (61)	26 (66)	28 (71)	30 (76)	32 (81.5)
Back length	8½ (21.5)	9½ (24)	10½ (26.5)	12½ (31.5)	14 (35.5)	15 (38)
Back width	8½ (22)	9½ (24)	10¼ (26)	11 (28)	11½ (29)	12 (30.5)
One shoulder	2¾ (7)	3 (7.5)	3⅜ (8.5)	3⅝ (9)	3¾ (9.5)	4 (10)
Waist to underarm	4 (10)	4 (10)	4½ (11.5)	6¼ (16)	7½ (19)	8 (20.5)
Wrist to underarm	8½ (21.5)	10½ (26.5)	11½ (29)	12¾ (31.5)	13¾ (34.5)	15 (38)
Armhole depth	4¼ (11)	5½ (14)	6 (15)	6¼ (16)	6½ (16.5)	7 (18)
Upper arm circumference	7½ (19)	8 (20.5)	8¼ (21.5)	9 (23)	9⅜ (24)	9¾ (25)
Wrist circumference	5¼ (13.5)	5½ (14)	5½ (14)	5¾ (14.5)	6 (15)	6 (15)
Head circumference	18 (45.5)	19 (48.5)	20 (51)	20 (51)	20 (51)	21 (53.5)

Note: Head circumferences are general guidelines only; a 2-year-old may have a 20" (51-cm) circumference and a 12-year-old may have a 22" (56-cm) circumference.

Misses (measurements are in inches with centimeters in parentheses)

Size	6	8	10	12	14	16	18
Bust	30½ (77.5)	31½ (80)	32½ (82.5)	34 (86.5)	36 (91.5)	38 (96.5)	40 (101.5)
*Full Bust	32½ (82.5)	33½ (85)	34½ (87.5)	36 (91.5)	38 (96.5)	40 (101.5)	42 (106.5)
Waist	23 (58.5)	24 (61)	25 (63.5)	26½ (67)	28 (71)	30 (76)	32 (81.5)
Hip	32½ (82.5)	33½ (85)	34½ (87.5)	36 (91.5)	38 (96.5)	40 (101.5)	42 (106.5)
Back length	15½ (39.5)	15¾ (40)	16 (40.5)	16¼ (41.5)	16½ (41.5)	16¾ (42.5)	17 (43)
Back width	13½ (34)	13½ (34)	14 (35.5)	14½ (37)	15 (38)	15½ (39.5)	16 (40.5)
One shoulder	4¾ (12)	4¾ (12)	5 (12.5)	5 (12.5)	5 (12.5)	5¼ (13.5)	5¼ (13.5)
Waist to underarm	8½ (21.5)	8¾ (22)	8¾ (22)	8¾ (22)	8¾ (22)	8¾ (22)	9 (23)
Wrist to underarm	16¾ (42.5)	16¾ (42.5)	17 (43)	17½ (44.5)	17¾ (45)	18 (45.5)	18¼ (46.5)
Armhole depth	7 (18)	7 (18)	7½ (19)	7½ (19)	7½ (19)	8 (20.5)	8 (20.5)
Upper arm circumference	9¾ (25)	9¾ (25)	10¼ (26)	10½ (26.5)	11 (28)	11½ (29)	12 (30.5)
Wrist circumference	6 (15)	6 (15)	6¼ (16)	6¼ (16)	6½ (16.5)	6½ (16.5)	6½ (16.5)
Head circumference	20–22" (51–56 cm) as a general guideline; 20" (51 cm) is considered small, 21" (53.5 cm) medium, and 22" (56 cm) large.						

*Note: The seemingly small bust measurements for Misses' sizes are those given by the National Bureau of Standards, and are most useful to those who sew. These measurements are taken around the chest above the full part of the breast, and allow an additional 1–3" (2.5–7.5 cm) to accommodate A, B, and C cup sizes that contribute to the full bust circumference. These amended measurements reflect an average measurement taken across the fullest part of the bust, and should be used to determine sizes for knitted garments.

Women (measurements are in inches with centimeters in parentheses)

Size	38	40	42	44	46	48	50
Bust	42 (106.5)	44 (112)	46 (117)	48 (122)	50 (127)	52 (132)	54 (137)
Waist	35 (89)	37 (94)	39 (99)	41½ (105.5)	44 (112)	46½ (118)	49 (124.5)
Hip	44 (112)	46 (117)	48 (122)	50 (127)	52 (132)	54 (137)	56 (142)
Back length	17¼ (44)	17⅜ (44)	17½ (44.5)	17½ (44.5)	17¾ (45)	17¾ (45.5)	18 (45.5)
Back width	16½ (42)	17 (43)	17½ (44.5)	18 (45.5)	18 (45.5)	18½ (47)	18½ (47)
One shoulder	5½ (14)	5½ (14)	5½ (14)	5¾ (14.5)	6 (15)	6¼ (16)	6¼ (16)
Waist to underarm	9 (23)	9 (23)	9¼ (23.5)	9¼ (23.5)	9⅜ (24)	9½ (24)	9⅞ (25)
Wrist to underarm	18¼ (46.5)	18¼ (46.5)	18¼ (46.5)	18¼ (46.5)	18¼ (46.5)	18¾ (46.5)	18¾ (46.5)
Armhole depth	8¼ (21)	8¼ (21)	8¼ (21)	8½ (21.5)	8½ (21.5)	8⅝ (22)	8⅝ (22)
Upper arm circumference	13 (33)	13½ (34.5)	14 (35.5)	15 (38)	15¾ (40)	16½ (42)	17 (43)
Wrist circumference	6⅝ (17)	7 (18)	7¼ (18.5)	7½ (19)	7⅝ (19.5)	8 (20.5)	8 (20.5)
Head circumference	20-22" (51-56 cm) as a general guideline; 20" (51 cm) is considered small, 21" (53.5 cm) medium, and 22" (56 cm) large.						

Men (measurements are in inches with centimeters in parentheses)

Size	34	36	38	40	42	44	46	48
Chest	34 (86.5)	36 (91.5)	38 (96.5)	40 (101.5)	42 (106.5)	44 (112)	46 (117)	48 (122)
Waist	28 (71)	30 (76)	32 (81.5)	34 (86.5)	36 (91.5)	39 (99)	42 (106.5)	44 (112)
Hip	35 (89)	37 (94)	39 (99)	41 (104)	43 (109)	45 (114.5)	47 (119.5)	49 (124.5)
Back length	22 (56)	23 (58.5)	24 (61)	25 (63.5)	26 (66)	26½ (67.5)	27½ (70)	28½ (72.5)
Back width	15½ (39.5)	16 (40.5)	16½ (42)	17 (43)	17½ (44.5)	18 (45.5)	18½ (47)	19 (48.5)
One shoulder	5 (12.5)	5¼ (13.5)	5½ (14)	5½ (14)	5½ (14)	6 (15)	6 (15)	6 (15)
Wrist to underarm	17½ (44.5)	18 (45.5)	18½ (47)	19 (48.5)	19½ (49.5)	20 (51)	20 (51)	20½ (52)
Waist to underarm	14 (35.5)	14½ (37)	15 (38)	15½ (39.5)	16 (40.5)	16 (40.5)	16½ (42)	17 (43)
Armhole depth	8 (20.5)	8½ (21.5)	9 (23)	9½ (24)	10 (25.5)	10½ (26.5)	11 (28)	11½ (29)
Upper arm circumference	13 (33)	13½ (34.5)	14 (35.5)	14½ (37)	15½ (39.5)	16 (40.5)	16½ (42)	17 (43)
Wrist circumference	6¼ (16)	6½ (16.5)	6¾ (17)	7 (18)	7¼ (18.5)	7½ (19)	7¾ (19.5)	8 (20.5)
Head circumference	21–23" (53.5–58.5 cm) as a general guideline; 21" (53.5 cm) is considered small, 22" (56 cm) medium, and 23" (58.5 cm) large.							

Sweater Ease Allowances

The following standard ease allowances were developed by the National Bureau of Standards in the 1950s, when fashion called for trim, close-fitting clothes. Styles fluctuate and the amount of ease in a "normal fit" today may more closely resemble a "loose fit" on the chart. Pay more attention to the actual measurements and percentages than the labels to achieve the desired results.

(measurements are in inches with centimeters in parentheses)

Size	Finished Chest/Bust Measurements				
Bust/Chest	Body Hugging minus 5-10%	Close Fit plus 0-5%	Normal Fit plus 7-10%	Loose Fit plus 12-15%	Oversized plus 16-20% or more
31-33 (79-84)	30 (76)	32 (81.5)	34 (86.5)	36 (91.5)	more than 36 (91.5)
33-35 (84-89)	32 (81.5)	34 (86.5)	36 (91.5)	38 (96.5)	more than 38 (96.5)
35-37 (89-94)	34 (86.5)	36 (91.5)	38 (96.5)	40 (101.5)	more than 40 (101.5)
37-39 (94-99)	36 (91.5)	38 (96.5)	40 (101.5)	42 (106.5)	more than 42 (106.5)
39-41 (99-104)	38 (96.5)	40 (101.5)	42 (106.5)	44 (112)	more than 44 (112)
41-43 (104-109)	40 (101.5)	42 (106.5)	44 (112)	46 (117)	more than 46 (117)

Weights and Lengths

Most yarn labels include weight and length information, but not always in both metric and English systems. Check out the weights and lengths charts for the most common conversions, or use the conversions charts and your handy calculator for any other numbers. For example, if a ball of yarn contains 167 meters, simply multiply 167 by 1.0936 to find out that it contains 182.6 yards.

Conversions

Ounces = grams × 28.35
Grams = ounces × 0.035
Inches = centimeters × 2.54
Yards = meters × 0.914
Centimeters = inches × 0.3937
Meters = yards × 1.094

Weights

¾ oz = 21.5 grams
1 oz = 28.5 grams
1½ oz = 43 grams
1¾ oz = 50 grams
2 oz = 57 grams
3½ oz = 100 grams

Lengths

Yards to Meters			Meters to Yards		
5	=	4.5	5	=	5.5
50	=	46	50	=	54.5
100	=	91	100	=	109.5
150	=	137	150	=	164
200	=	183	200	=	218.5
300	=	274	300	=	328
400	=	366	400	=	437.5

Winding yarn

Yarn is sold in balls, skeins, and hanks. Balls and skeins are wound so that the yarn can be pulled from the center or out-side. A hank is a large ring of yarn that is twisted on itself, like a rope. Before you can knit with yarn from a hank, you'll need to wind it into a ball.

Ball

Skein

Hank

WIND YARN BY HAND

Untwist the hank and place the ring of yarn between a friend's hands and cut apart any ties holding the hank together. Place one end of the hank yarn in your palm and hold it securely with your ring and little fingers. You'll use this end to knit with. Wind the yarn around your index and middle fingers until you have a small "wad" of yarn. Then turn the wad in your hand, hold the center with your thumb, and con-tinue to wind, rotating the ball in your hand to evenly distribute the yarn around the growing ball. Finish by tucking the end under a few strands on the outside of the ball. To knit, pull the end of the working yarn from the center of the ball.

WIND WITH A SWIFT AND BALL WINDER

You'll get the job done much more quickly with a yarn swift and ball winder. A swift is an expand-able contraption, much like an umbrella, that holds a hank of yarn. The end of the yarn is attached to a ball winder and by simply turning the crank, you can create a sturdy center-pull ball.

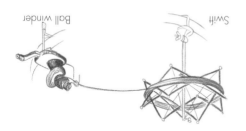

Swift

Ball winder

Knitting Needle Size Conversions

US	Metric	UK
0	2 mm	14
1	2.25 mm	13
	2.5 mm	
2	2.75 mm	12
	3 mm	11
3	3.25 mm	10
4	3.5 mm	
5	3.75 mm	9
6	4 mm	8
7	4.5 mm	7

US	Metric	UK
8	5 mm	6
9	5.5 mm	5
10	6 mm	4
10½	6.5 mm	3
	7 mm	2
	7.5 mm	1
11	8 mm	0
13	9 mm	00
15	10 mm	000

Crochet Hook Size Conversions

Aluminum, Plastic, Bone, Wood

US	Metric	UK
B/1	2.25 mm	13
	2.5 mm	
C/2	2.75 mm	12
	3 mm	11
D/3	3.25 mm	10
E/4	3.5 mm	9
F/5	3.75 mm	8
	4 mm	
G/6	4.25 mm	7
	4.5 mm	
H/8	4.75 mm	6
	2 mm	14

US	Metric	UK
	5 mm	
I/9	5.5 mm	5
J/10	6 mm	4
K/10½	6.5 mm	3
	7 mm	2
	7.5 mm	
L/11	8 mm	
M/13	9 mm	
N/15	10 mm	
P/16	15 mm	
Q	16 mm	
S	19 mm	

Steel

US	Metric	UK
00	3.5 mm	
0	3.25 mm	0
1	2.75 mm	1
2	2.25 mm	1½
3	2.1 mm	2
4	2 mm	2½
5	1.9 mm	3
6	1.8 mm	3½
7	1.65 mm	4
8	1.5 mm	4½
9	1.4 mm	5
10	1.3 mm	5½
11	1.1 mm	6
12	1 mm	6½
13	0.85 mm	7
14	0.75 mm	

Abbreviations

A

alt	alternate
approx	approximately

B

b	bobble
bc	back cross
beg	begin(s); beginning
bet	between
BO	bind off
but	buttonhole

C

cab	cable
CC	contrasting color
ch	chain
cm	centimeter(s)
cn	cable needle
CO	cast on
col	color
cont	continue(s); continuing
cr l	cross left
cr r	cross right

D

dbl	double
dc	double crochet
dec(s)	decrease(s); decreasing
diag	diagonal
diam	diameter
DK	double knitting
dpn	double-pointed needle
dtr	double treble crochet

E

e	every
eor	every other row
eon	end of needle

F

FC	front cross
fin	finished
foll	following

G

g	gram(s)
grp	group(s)
g st	garter stitch

H

hdc	half double crochet
hk	hook
htr	half treble crochet

I

in(s)	inch(es)
inc(s)	increase(s); increasing
incl	including
inst	instructions

K

k	knit
kbl (k tbl)	knit through back loop of a stitch
kfb (k1f&b)	knit into the front and back of a stitch
k2tog	knit two stitches together
kwise	knitwise

L

l	left
LC	left cross
lh	left hand
ln	left needle
lp(s)	loop(s)
LT	left twist

M

m	meter(s)
mb	make bobble
MC	main color
med	medium
mm	millimeters
M1	make one
mult	multiple

27

N

no	number

O

o	other
opp	opposite
oz	ounce(s)

P

p	purl
patt(s)	pattern(s)
p-b	purl into the stitch in the row below
pfb (p1f&b)	purl into the front and back of next stitch
pm	place marker
pnso	pass next stitch over
psso	pass slip stitch over
p tbl	purl through back loop of stitch
p2tog	purl two stitches together
p2tog-b	purl two stitches together through back of loop
pwise	purlwise

R

RC	right cross
rem(s)	remain(s); remaining
rep	repeat
rev St st	reverse stockinette stitch
rh	right hand
rib	ribbing
rnd(s)	round(s)
RS	right side
RT	right twist

S

sc	single crochet
sel	selvedge
sk	skip
skn	skein
skp	slip one, knit one, pass slip stitch over (one stitch decreased)
sl	slip
sl st	slip(ped) stitch
sp	space
ssk	slip, slip, knit (one stitch decreased)
ssp	slip, slip, purl (one stitch decreased)
st(s)	stitch(es)
St st	stockinette stitch

T

tbl	through back loop of stitch
tch	turning chain
tog	together
tr	treble crochet

W

won	wool over needle
wrn	wool round needle
ws	wrong side
wyb (wyib)	with yarn in back
wyf (wyif)	with yarn in front

Y

yb	yarn back
yf	yarn forward
yfon	yarn forward and over needle
yfrn	yarn forward and round needle
yo	yarn over
yon	yarn over needle
yo2	yarn over twice
yrn	yarn round needle
ytb	yarn to back
ytf	yarn to front

Z

z	zipper

*	repeat starting or stopping point (i.e., repeat from *)
* *	repeat all instructions between asterisks
()	alternate measurements and/or instructions
[]	alternate measurements and/or instructions; also used to indicate instructions that are to be worked as a group a specified number of times

THE BASICS

Continental Method

In the Continental method of knitting, the working yarn is held stable in the left hand while the right hand directs the needle to make stitches. This method is noted for its speed and ease of execution, particularly when switching the working yarn from front to back to change from knit to purl, as for ribbing.

Knit stitch

Hold the needle with the cast-on stitches in your left hand.

1. Hold the working yarn in back of the needle, over your left index finger, and in your palm against the needle (or around your little finger) for tension.

2. Insert the right needle into the first stitch, from front to back. Catch the working yarn by moving the right needle over and behind it.

3. Pull the working yarn through the stitch to the front. Leaving the newly formed stitch on the right needle, slip the old stitch off the left needle.

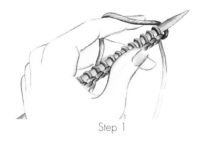

Step 1

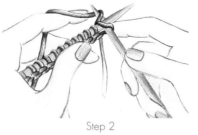

Step 2

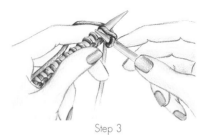

Step 3

PURL STITCH

Hold the needle with the cast-on stitches in your left hand. Hold the working yarn in your left hand, over your index finger, and in your palm against the needle (or around your little finger) for tension.

1. Holding the working yarn in front of the needle, insert the right needle into the first stitch, from back to front.

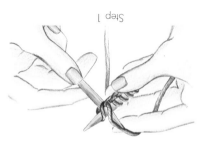

Step 1

2. With your left index finger, lay the working yarn over the right needle from front to back, and then down between needles.

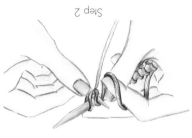

Step 2

3. Leverage the right needle to the back, through the cast-on stitch. Leaving the newly formed stitch on the right needle, slip the old stitch off the left needle.

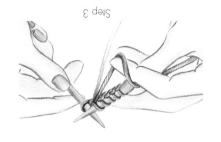

Step 3

English Method

In the English method, the working yarn is held in the right hand, and is thrown or passed around the needle.

Knit Stitch

Hold the needle with the cast-on stitches in your left hand. Hold the working yarn in your right hand, over your index finger and wound around your little finger for tension.

1. With the working yarn held in back, insert the right needle into the first stitch on the left needle, from front to back.
2. Use your right hand to wrap the yarn under and around the needle.
3. Pull the wrapped needle back through the cast-on stitch to the front. Leaving the newly formed stitch on the right needle, slip the old stitch off the left needle.

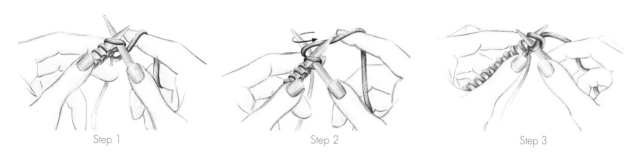

Step 1 Step 2 Step 3

Purl Stitch

Hold the needle with the cast-on stitches in your left hand. Hold the working yarn in your right hand, over your right index finger and wound around your right little finger for tension.

1. Holding the working yarn in front of the needle, insert the right needle into the first stitch, from back to front.

2. Wrap or "throw" the working yarn behind and around the right needle in a counterclockwise motion.

3. Leverage the right needle back through the stitch. Leaving the newly formed stitch on the right needle, slip the old stitch off the left needle.

Step 1 Step 2 Step 3

Slipped Stitches

To slip a stitch, simply pass it from one needle to the other without knitting or purling it. Beginners commonly try to overthink this little move, expecting it to be more than it is. Slipped stitches are often used in decreases and decorative stitch patterns. Unless a pattern specifies otherwise, slip stitches purlwise.

PURLWISE

Insert the right needle into the first stitch on the left needle as if you were to purl it, then slip it off the left needle and onto the right.

KNITWISE

Insert the right needle into the first stitch on the left needle as if you were to knit it, then slip it off the left needle and onto the right.

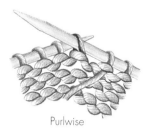
Purlwise

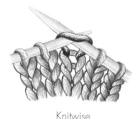
Knitwise

Yarnovers

Yarnovers produce open increases. You'll avoid confusion if you think of them as being worked in two steps. The first step is to lay the yarn from front to back over the needle. The second step is to place the working yarn in front of or behind the needle in preparation for the next stitch.

After a knit stitch

If the working yarn follows a knit stitch on the right needle, bring the yarn forward under the needle, then lay it over the needle, from front to back.

If the working yarn follows a purl stitch, the yarn is already in the front and you can simply lay it over the needle, from front to back. If the stitch following the yarnover is to be knitted, leave the working yarn in back of the needles; if the next stitch is to be purled, bring the working yarn to the front of the needles.

After a purl stitch

Gauge

Gauge, or tension, is the most critical factor in obtaining an accurate fit. All patterns are based on a specific number of stitches and rows per inch of knitting. If your knitting doesn't match that specification, your garment stands little chance of fitting properly. When I was young, being quite the knitter that I was, I thought I was "beyond gauge." I merrily knitted my way to a big piece of humble pie, with a garment wide enough for a football player and short enough for a toddler. Having been cured of this arrogance, I have forevermore enjoyed knitting gauge swatches!

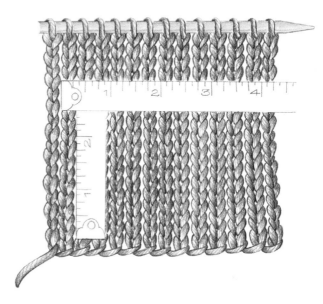

To determine gauge, knit a sample swatch with the yarn and needles you intend to use for the garment. Always knit a swatch at least 4" (10 cm) wide and 4" (10 cm) long, even if the pattern you plan to follow specifies a gauge of a certain number of stitches over just 1" (2.5 cm). Because the stitches at the edges of the knitting tend to be somewhat misshapen, you'll want to measure at least two stitches in from the selvedge edges of the swatch. Therefore, cast on at least four more stitches than needed to make 4" (10 cm) of knitting width. Work the pattern stitch specified to check the gauge; if no pattern is given, work the swatch in stockinette stitch. If the pattern is complex, such as Aran or lace, you should work a larger swatch, perhaps 8" (20.5 cm) square.

To measure the gauge, lay the swatch flat, place a tape measure or ruler parallel to a row of stitches, and count the number of stitches (including fractions of stitches) that are in 4" (10 cm). This is your stitch gauge per 4" (10 cm). Compare this gauge to that specified by the pattern. If your swatch has too few stitches, your work is too loose and you should try again with smaller needles. If your swatch has too many stitches, your work is too tight and you should try again with larger needles.

When your gauge matches that specified by the pattern, you are ready to begin knitting. But don't throw away your swatch. Instead, bind off the stitches and use it to test the washability of the yarn, put it in a notebook with other swatches for future reference, use it with other swatches to make a patchwork afghan, or use it for practicing edgings or embroidery.

If you want to reuse the yarn in the gauge swatch, ravel the swatch and wrap the yarn around the outside of the ball. Begin knitting with another ball to give the raveled yarn time to relax.

Measuring the Knitting

To measure knitting length, as in ribbing, garment, or sleeve length, lay the piece on a flat surface and without stretching it, measure the center of the piece from the bottom edge to the lower edge of the knitting needle.

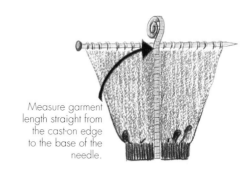

Measure garment length straight from the cast-on edge to the base of the needle.

To measure a shaped edge, such as an armhole or a sleeve, measure on the straight of grain (perpendicular to the bottom edge). For example, measure an armhole by laying a ruler or other straight edge horizontally across the garment, even with the first row of stitches bound off for the armhole. From that straight edge, measure vertically to the lower edge of the knitting needle. *Do not* follow along the slanted, shaped side edge! Erroneous measuring can result in sleeves that are too short, armholes that are too shallow, and an overall appearance of being squeezed into your sweater. Not an attractive sight. . . .

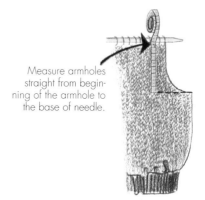

Measure armholes straight from beginning of the armhole to the base of needle.

Reading Patterns and Charts

PATTERNS

Patterns are divided into information segments: sizes, materials, gauge, and instructions for each piece, such as back, front, and sleeves. Most patterns end by detailing how to assemble and embellish the project.

Finished size You'll find size information at the beginning of a pattern, with parentheses—()— used to indicate alternate measurements; forward slashes—/— used to separate method of definition. For example, chest/bust finished size 36 (40, 44)"/ 92 (102,112) cm reads as: Man's chest or woman's bust finished circumference across the fullest part of the chest just under the armhole is 36" for the smallest size, 40" for the next size, 44" for the third size; 92 cm for the smallest size, 102 cm for the middle size, and 112 cm for the largest size. The size you choose determines which set of numbers you'll follow for the rest of the pattern. For knitting the second size, you will follow the first number inside of the parentheses wherever there is a choice in the text. If there is only one number, all sizes are worked the same.

Abbreviations Use the Abbreviations list (see page 27) to decipher word fragments or letter groups as you read through the pattern.

Asterisks Asterisks, —*— are used to indicate parts of the pattern that are repeated. For example, "K1, *K1f&b, p6, knit 10*, rep from * to * three times, end p1" tells you to begin the row with a knit stitch, then work the part "knit into the front and back of the next stitch, purl 6 stitches, knit 10 stitches" for a total of four times (the first time and three repeats), then purl the last stitch.

Brackets Brackets—[]—may be used for alternate measurements, as well as to indicate instructions that are to be worked as a group for a specific number of times. For example, "[k1, k2tog] 12 times" means that you "knit one, then knit two together" as a unit 12 times before moving on.

Before you start knitting, read all the way through a pattern to help you visualize the pattern progression, and eliminate surprises that may require raveling some of your work. The phrase "at the same time" can virtually put your motivation in reverse if you miss a step. For example, instructions for a left front may read: "At armhole edge, bind off 4 sts 1 time, 2 sts 2 times, then decrease 1 st every other row 4 times. AT SAME TIME, decrease 1 st at neck edge every 4th row 10 times." For clarity, the instructions for the armhole must be written separately from the neck shaping, but they are worked in simultaneous progression through the work. You would work these rows as follows:

Row 1: Bind off 4 sts, knit to the last 3 sts, k2tog, k1.
Row 2: Purl to end of row.
Row 3: Bind off 2 sts, knit to end of row.
Row 4: Purl to end of row.
Row 5: K1, ssk, knit to last 3 sts, k2tog, k1.
Row 6: Purl to end of row.
Row 7: K1, ssk, knit to end of row.
Row 8: Purl to end of row.
You get the idea; some shaping decreases happen in the same row, some do not.

Reverse shaping Some patterns will tell you to "reverse shaping" when the second piece of knitting should be worked as a mirror image of the first. For example, after giving detailed instructions for working the left front, the pattern may read "Make right front to match, reversing all shaping." In knitting the left front, you would have shaped the armhole and shoulder by binding off or decreasing stitches at the beginning of right-side rows, and you would

have shaped the neck by decreasing stitches at the end of right-side rows or by binding off or decreasing stitches at the beginning of wrong-side rows. To reverse this shaping for the right front, you'll want to bind off for the armhole and shoulder at the beginning of *wrong-side* rows and bind off for the neck at the beginning of *wrong-side* rows. Decreases may be worked at the beginning or end of either right- or wrong-side rows.

Work new stitches into pattern Sometimes you will work a stitch pattern at the same time as increases are made. If the instructions say "work new stitches into pattern," you'll want to incorporate the new stitches in the established pattern. For most simple stitch patterns, you can work the new stitches into the pattern as soon as they are made. For more complicated patterns, you'll want to work the new stitches in stockinette stitch until you've increased enough to work an entire new pattern repeat.

Work even When a pattern tells you to "work even" or "knit even" or "continue as established" for a specific number of rows or inches, simply maintain the pattern stitch you're already working, without increasing or decreasing any stitches.

CHARTS

Charts are a visual guide to color or stitch motifs. They are usually presented on square graph paper with one square representing one stitch, even though knitted stitches are slightly wider than they are tall. Keep this in mind if you plan to design your own charted motifs—the knitted motif may appear shorter and wider than the charted design. Charts may be in color with pictures or patterns defined with different colors of yarns, as with Fair Isle or intarsia. Most often these are worked in the smooth texture of stockinette stitch, with knit stitches forming the right side of the work. Or charts may have many different symbols representing different tex-

Texture sample

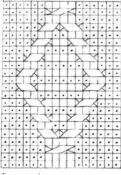

Texture chart

Fair Isle sample

Fair Isle chart

tures of stitches, such as Aran knits. A key is given to indicate the color or stitch represented by each color or symbol. Unless otherwise noted, charts should be read from bottom to top. Read charts from right to left on right-side rows; from left to right on wrong-side rows. When knitting circularly in rounds, read all rows of charts from right to left. Many charts include heavy repeat lines that indicate sections that are to be repeated. Charts may be annotated with notes to indicate starting and ending points for various sizes.

You may find that the biggest challenge to reading a chart is keeping your place. To help yourself, place the chart on a magnet board equipped with a magnetic straight edge (available from needlework shops). If you place the straight edge just above the row you are working on, you will be able follow the row you're working on as well as see the rows already completed, giving you a point of reference for subsequent color or texture changes.

CAST-ONS

The cast-on row is the foundation for the knitting. There are a variety of ways to cast on; the most common are outlined here.

TIP: The ribbing in most sweater styles is worked on 10–20% fewer stitches than used in the body of the sweater, and is commonly worked on needles two or even three sizes smaller than used for the body. Within these guidelines, the greater the difference in the number of stitches and sizes of needles used for the ribbing and body, the tighter the ribbing will be. Determine the style of fit you prefer, and then adjust the number of stitches and needle size accordingly.

TIP: If you tend to cast on tightly, use a needle one, two, or even three sizes larger than the recommended needle, and then remember to switch to the correct needle size when you begin knitting.

Slipknot

Do you remember the "magic" knot you learned as a child? With just a snap of your wrist the knot would disappear. Almost all cast-on methods begin with this knot.

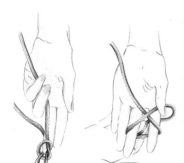

With the tail end of the yarn in your palm, wrap the working yarn around your index and middle fingers, and lay the working yarn across the tail end, forming an "x." Spread your fingers slightly and push the working yarn through your fingers from the back of your hand. Pull this loop up slightly while holding the tail end of the yarn to form a knot. Place the loop onto the knitting needle and pull working yarn to adjust the tension.

Backward Loop or E Cast-On

This is a great method for increasing a single stitch or to cast on just a few stitches for shaping. However, it does not produce a stable edge for garment beginnings.

If there are no stitches to begin with, place a slipknot (see page 42) on the right needle.

1. Wrap the working yarn around your thumb from front to back and secure in your palm with your fingers.
2. Insert the needle upward into the strand on the front of the thumb.

3. Release the resulting loop onto the needle and pull gently with the left hand to adjust for tension.

Repeat Steps 1–3 until you have the desired number of stitches.

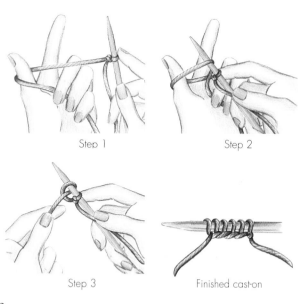

Step 1

Step 2

Step 3

Finished cast-on

43

Long-Tail Cast-On

The long-tail cast-on (also called the Continental cast-on), probably the most common method, creates a firm but elastic edge. The stitches produced by this method look like knit stitches on one side and like purl stitches on the other. I like to have the smooth sides of the cast-on stitches on the right side of my garments, so when I use this method, I make my first row of knitting a wrong-side row.

> **TIP:** A simple way to figure out how long to make the tail is to wrap the yarn around the needle, one wrap per stitch to be cast on. You can simplify this by wrapping the needle just 20 times to determine the length needed for 20 stitches and then multiply this length by the number of times 20 goes into the total number of stitches needed. Of course, it's always a good idea to leave a little extra for seaming.
>
> Example: 100 stitches needed divided by
> 20 wraps = 5 lengths, plus a little.

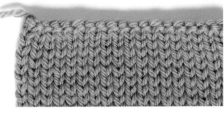

Bumpy (purl) side of cast-on.

Smooth (knit) side of cast-on.

1. Leaving the determined length for a tail (see Tip page 44), make a slipknot (see page 42) with the yarn and place it on a knitting needle held in your right hand. Place the tail end of yarn over your left thumb and the working end over your left index finger. Turn your hand and needle to a vertical position, catching the yarn in your palm with your remaining fingers.

2. Insert the needle upward into the loop that is on your thumb, catch the working yarn on your index finger by moving the needle over the yarn, then press the needle downward back through the loop on your thumb.

3. Remove your thumb from the loop.

4. Adjust the tension of the resulting stitch by pulling on the needle gently while repositioning your thumb under the tail end of the yarn in prepara-

tion for the next stitch. You should not have to let go of the yarn secured in your palm.

Repeat Steps 2–4 until you have the desired number of stitches.

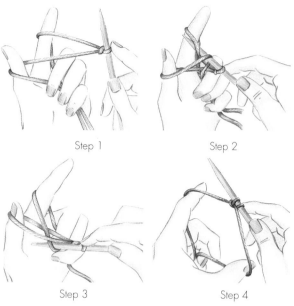

Step 1 Step 2

Step 3 Step 4

Cable Cast-On

The cable cast-on produces a smooth, twisted cable effect viewed from either side. Because it is not very elastic, this cast-on is best suited for afghans, scarves, and cropped sweaters or jackets that have no ribbing.

Leaving an 18" (45-cm) tail for seaming, make a slipknot (see page 42) and place it on a knitting needle held in your left hand. Insert the right needle into the slipknot as if to knit. Pull a loop forward and place it on the left needle.

1. Insert the right needle between the two stitches and wrap yarn around the needle as if to knit.
2. Pull the loop forward.
3. Place the loop on the left needle.

Repeat Steps 1–3, working between the last two stitches on the needle, until you have the desired number of stitches.

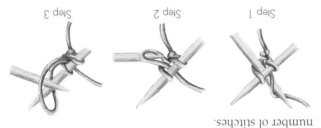

Step 1 Step 2 Step 3

TIP: To eliminate the inevitable hole in the first stitch in a body of work, use the knitted method (see page 47) to cast on the first stitch, then use the cable method for the others. Knit into the back of the knitted cast-on loop on the next row.

TIP: Insert the right needle between the two stitches *before* you pull the working yarn for tension.

Knitted Cast-On

The knitted method is an effective cast-on for adding stitches to shape a work in progress, especially if the cast-on stitches will be secured in a seam later. This method is similar to the cable cast-on (see page 46), but not quite as sturdy for an exposed edge.

1. Leaving an 18" (45-cm) tail for seaming, begin by making a slipknot (see page 42) and placing it on a knitting needle held in your left hand.

2. Insert the right needle into the slipknot as if to knit, pull a loop forward, and place it on the left needle.

3. Insert the right needle into the new stitch, wrap the yarn around the needle as if to knit and pull the loop forward.

4. Place the loop on the left needle.

Repeat Steps 3 and 4, always working into the last stitch made, until you have the desired number of stitches.

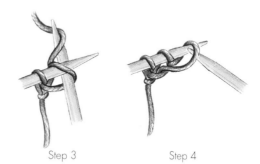

Step 3 Step 4

Crochet Chain Provisional Cast-On

This is my favorite temporary cast-on. I use it whenever I'll need live stitches for later details (such as ribbings, borders, and hems).

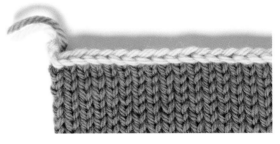

1. With a contrasting color of waste yarn the same size as your working yarn, make a crochet chain several stitches longer than the number of stitches needed to cast on. Pull cut end of waste yarn through last chain very loosely to avoid raveling before you are ready.

2. With the working yarn, pick up and knit one stitch in each of the "bumps" on the wrong side of the crochet chain until you have the desired number cast on.

When you're ready to work the cast-on stitches in the opposite direction, pull out the crochet chain (beginning with the last loosely secured chain stitch) and place the exposed live stitches on a needle.

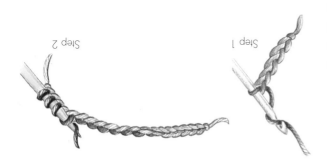

Step 1

Step 2

Invisible or Open Cast-On

This is another good way to temporarily cast on stitches.

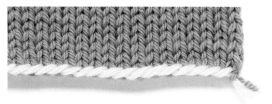

To begin, knot the working yarn to a length (a yard is usually sufficient) of contrasting waste yarn. Hold the knot against the knitting needle with your right thumb.

1. Hold the yarns in your 1eft hand with the working yarn over the needle and the waste yarn over your thumb.

2. Work as for the long-tail method (see page 45), inserting the right needle up into the waste yarn on your thumb, around the working yarn on your index finger, and down through waste-yarn loop on your thumb.

3. Remove your thumb from the loop and pull the needle gently to adjust the tension.

Repeat Steps 2 and 3 until you have the desired number of stitches.

When you are ready to knit, graft, or hem the stitches, use scissors to clip the waste yarn, and place the resulting loops on a needle.

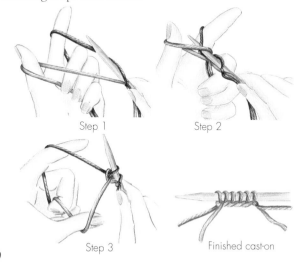

Step 1

Step 2

Step 3

Finished cast-on

49

JOINING YARNS

Joining at the Side Edge

This joining technique works well with all types of yarn.

METHOD 1

Simply drop the old ball and begin to knit with the new, leaving 6" (15-cm) tails of each to be worked in later. This method has the advantages of uninterrupted rows, no double thickness of yarn, and no knot at the side seam, which makes it especially good for bulky yarns. The disadvantage is that the work feels loose and unstable and the ends of yarn have to be pulled to maintain the tension of the end stitches.

METHOD 2

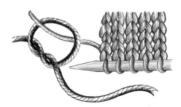

For a more secure join, tie a new ball onto the old ball at the side edge using the first half of a square knot. Then slide the half-knot up to just behind the stitch on the needle and continue knitting with the new ball of yarn. This method has the advantage of uninterrupted knitted rows and feels quite stable where the new ball begins. The disadvantage is that there is the bulk of the half-knot in the seam. This method works on virtually all yarns, but is especially useful when working with slippery yarns such as cotton and silk, or when working lace or openwork patterns.

Overlapping the Old and New Yarn

Use this joining method in an inconspicuous place, such as 1–2" (2.5–5 cm) in from the side edge or in a textured area. This method is well suited for wools, synthetics, blends of any kind, and novelty yarns that are worsted-weight or finer. When worked with nonelastic yarns such as cotton and ribbon yarn, this join may be visible from the right side.

1. Overlap the end of the old ball and the beginning of the new for about 6" (15 cm).

2. Work two stitches with the two strands held together as if they were a single strand.

3. Drop the strand from the old ball and continue working with the new.

4. On the next row, work the double-stranded stitches as if they were single-strand stitches. During finishing, secure the two loose ends by weaving them diagonally into the wrong side of the knitted fabric (weaving them horizontally or vertically may create a visible ridge on the right side).

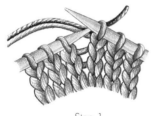

Step 1

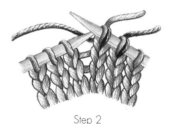

Step 2

Splicing

Splicing forms an invisible join that can be used anywhere in a row. It secures the two yarns together without adding bulk or knots, is easy to accomplish, and eliminates the need to work in ends.

UNPLIED YARNS (SINGLES)

Loosen the twist of the last 3" (7.5 cm) of the old ball by pulling sideways on the yarn to feather the ends. Prepare the first 3" (7.5 cm) of the new ball in same way. Overlap the old and the new along the untwisted sections and secure the feathered fibers around each other. Firmly twist the ends between your fingers to "felt" the fibers together. This method works well for yarns made from wool, llama, or alpaca fibers.

Unplied yarns

PLIED YARNS

1. Untwist the plies into two separate strands for about 4" (10 cm) from the ends of both the old and the new balls. Depending on the number of plies in the yarn, the separated strands may be made up of one or more individual plies.

2. Leaving one-half of the untwisted plies from each ball hanging, twist the other halves together to form a continuous plied yarn.

Continue knitting with the twisted yarn and weave in the loose plies later.

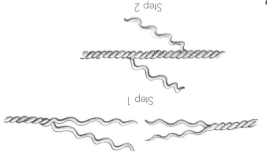

Step 1

Step 2

INCREASES

By adding stitches, one or two at a time, you can add width to a piece of knitting. Increases can be subtle or they can be quite visible and used decoratively. It is good to know several methods so you can choose the type that is most appropriate for your project.

When shaping garments, increases are usually made one or two stitches in from the edge of the knitting so that they don't interfere with the edge stitches that are used for seaming. Most patterns specify that increases be made on the right side of the work. This makes it easier to keep track of when to increase and allows you to see the increases that have been worked.

TIP: If you have trouble keeping track of your increases, or if for some reason you must increase on a wrong-side row, slip an open marker into each increase as it is completed, then simply count the markers. Alternatively, use a stitch counter or make a pencil mark on a piece of paper each time you make an increase.

Yarnover Increase (yo)

This decorative increase is typically used for lace patterns or to give a decorative look to garments such as dressy sweaters or baby clothes. A yarnover is made by simply wrapping the yarn over the needle to create a new stitch. The wrap is worked as if it were a regular stitch on the following row.

WORKED ON THE KNIT SIDE

On knit rows, the working yarn will be in back of the needles. Bring the yarn between the needles to

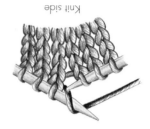

Knit side

the front, then over the right needle and again to the back to form a new stitch on the right needle and to position the yarn for the next knit stitch.

WORKED ON THE PURL SIDE

On purl rows, the working yarn will be in front of the needles. Lay the yarn over the top of the right needle, then bring it to the front between the needles to form a new stitch on the right needle and to position the yarn for the next purl stitch.

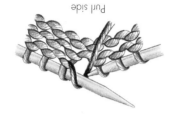

Purl side

Bar Increase (k1f&b or p1f&b)

This type of increase, abbreviated "k1f&b" or "p1f&b," is tight and tidy and derives its name from the small purl bar that forms on the right side of the knitting. Because it is very stable, it is a good choice for increasing on the last row of ribbing, just before the body of a sweater begins, so that the ribbing doesn't flair.

WORKED ON THE KNIT SIDE

Knit a stitch in the usual way, but don't slip it from the left needle. Knit through the back loop of the same stitch, then slip the old stitch from the left needle.

Knit side

WORKED ON THE PURL SIDE

Purl a stitch in the usual way, but don't slip it from the left needle. Purl through the back loop of the same stitch, then slip the old stitch from the left needle.

Purl side

Finished increase

Lifted or Raised Increase

This increase is nearly invisible and works well for all basic body and sleeves shaping. It's a two-part process involving working the stitch on the needle *and* the stitch below it; depending on which stitch you work first, you can make this increase slant, or tilt, to the right or left.

WORKED ON THE KNIT SIDE

Right-slant

1. Insert the right needle into the back of the loop of the stitch below (to see the back of the loop, tilt the knitting slightly toward you) and knit this stitch.

2. Knit the stitch on the needle.

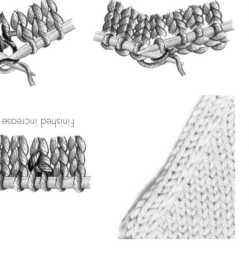

Step 1

Step 2

Finished increase

> **TIP:** A common mistake with the lifted or raised increase is to forget to work the stitch on the needle as part of the increase after working the stitch below—if you don't work both, you won't increase any stitches.

Left-slant

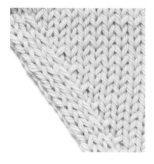

Finished increase

1. Knit the stitch as usual.
2. Insert left needle from the bottom into the back of the loop of the stitch in the row below the one just worked, and knit this stitch through the back of the loop.

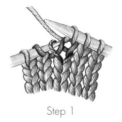

Step 1

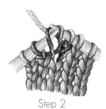

Step 2

WORKED ON THE PURLSIDE

On wrong-side rows, the lifted increase involves purling into the stitch below the stitch on the needle.

You may find it helpful to lift the stitch below onto the left needle so that you can use the needle to hold it as you purl it.

Right-slant
1. Purl the stitch as usual.
2. Insert left needle from the bottom into the purl stitch below the one just worked and purl it.

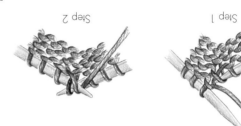

Step 1

Step 2

Left-slant
1. Insert the right needle from the top into the purl stitch below the stitch on the needle and purl this stitch.
2. Purl the stitch on the needle.

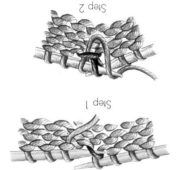

Step 1

Step 2

Make One (M1)

This increase makes a stitch out of the horizontal "ladder" that extends between every two stitches. This is a subtle increase that can slant either to the right or left, depending on the way you work the horizontal ladder. The versions are commonly used in tandem for shaping symmetry.

WORKED ON THE KNIT SIDE

Right-slant

1. Insert the left needle from back to front under the ladder.
2. Knit this lifted strand through the front to twist the stitch to the right.

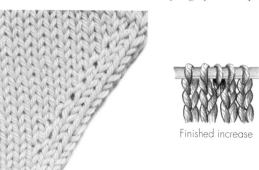

Finished increase

Step 1

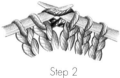

Step 2

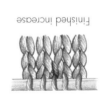

Step 1

Step 2

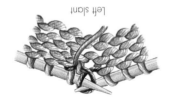

Left slant

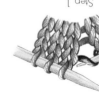

Finished increase

Left-slant

1. Insert the left needle from front to back under the ladder between the two needles.
2. Knit this lifted strand through the back to twist the stitch to the left.

Left-slant

Insert the left needle from front to back under the ladder. Purl this lifted strand through the back to twist the stitch to the left.

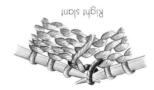

Right slant

WORKED ON THE PURL SIDE

Right-slant

Insert the left needle from back to front under the ladder. Purl this lifted strand through the front to twist the stitch to the right.

Double Increase

A double increase causes the work to widen at twice the rate as a single increase. It is generally worked on the right side of the knitting by working two increases, one on each side of a plain stitch, called the axis stitch. Double increases are generally worked in the middle of a piece, not at the sides. They can be used to shape garments worked from the neck down, for mitering corners, and for lace patterns. Increase one stitch immediately before the axis stitch, work the axis stitch, then increase one stitch immediately following the axis stitch. The type of increases to use depends on the look you want. For example, a double make-one increase (see page 59) might be used when mitering a corner where only a subtle effect is needed. A double yarnover increase (see page 54) may be used as a dressier textural design for raglan shoulder shaping when knitting from the neck down.

> **TIP:** All types of increases are visible in the knitted fabric, though they may subtle or quite prominent. Simply keep in mind the overall finished appearance you wish to achieve, and evaluate your choice of increase style based on how it blends in with the garment as a whole.

DOUBLE YARNOVER INCREASE

1. Work a yarnover (see page 54) immediately before the axis stitch.
2. Work the axis stitch.
3. Work a yarnover immediately after the axis stitch.

DOUBLE BAR INCREASE

1. Work a bar increase (see page 55) in the stitch preceding the axis stitch.
2. Work another bar increase in the axis stitch.

Double raised increase

This method involves working two raised increases (see page 56) into the axis stitch and looks somewhat like a raised rope cable.

1. Knit into the stitch in the row below the axis stitch by working into the purl loop behind the stitch on the needle.

2. Knit through the back of the loop of the axis stitch (to avoid a hole).

3. Knit again into the stitch in the row below by working into the purl loop behind the stitch on the needle.

DOUBLE MAKE-ONE INCREASE

This method uses the ladders immediately before and after the axis stitch.

1. Work a make-one, right-slant increase (see page 59) before the axis stitch.
2. Work the axis stitch.
3. Work a make-one, left-slant increase (see page 60) right after the axis stitch.

You can transpose Steps 1 and 3 for a different, but equally symmetrical, look.

DECREASES

Decreases subtract stitches, usually one or two at a time, to make a knitted piece narrower. The most popular methods are knit two together (k2tog), slip slip knit (ssk), and slip knit pass (skp). The k2tog and ssk decreases are mirror images of each other; one slants right, the other slants left. They are generally used in tandem for symmetrical shaping, such as armholes on sweaters or insteps on socks. For a polished look, many patterns will specify for the decreases to be worked two to four stitches in from the edge, as shown here. In general, use an ssk at the beginning of a row and a k2tog at the end of a row.

Knit Two Together (k2tog)

This subtle right-slanting decrease is worked on a knit row.

 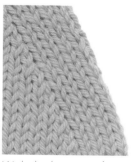

Worked at end of row Worked at beginning of row

Insert the right needle into two stitches (at the same time) knitwise and knit them as if they were a single stitch.

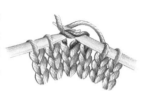

Slip Slip Knit (ssk)

This subtle left-slanting decrease is worked on a knit row and mirrors the shape of the k2tog decrease.

Worked at end of row

Worked at beginning of row

1. Slip two stitches individually knitwise onto the right needle.

2. Insert the left needle tip into the front of the two slipped stitches to hold them in place while you knit them together through their back loops with the right needle.

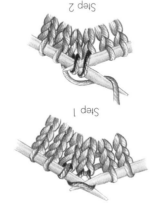

Step 1

Step 2

Slip Knit Pass (skp)

This decrease is worked on a knit row and produces a fairly pronounced left-slanting decrease. It is best used in lace patterns or with other textural stitches where a visible decrease is a necessary part of the finished look.

1. Slip one stitch knitwise, knit the next stitch.
2. Use the left needle tip to pass the slipped stitch up and over the knit stitch and off the right needle.

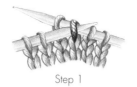

Step 1

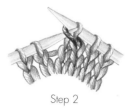

Step 2

Worked at end of row

Worked at beginning of row

TIP: To minimize the prominence of the decrease, avoid stretching the stitch as you pass it over.

Purl Two Together (p2tog)

This decrease is worked on a purl row and forms a right-slanting decrease on the knit side. It looks the same as k2tog decrease (see page 65) on the knit side.

Insert the right needle into two stitches together purlwise and purl them together as if they were a single stitch.

Slip Slip Purl (ssp)

This decrease is worked on a purl row and forms a left-slanting decrease on the knit side. It looks the same as an ssk decrease (see page 66) on the knit side.

Slip two stitches individually knitwise to the right needle. Return these two stitches to the left needle in their twisted orientation, then purl them together through their back loops.

Slip Purl Pass (spp)

This decrease is worked on a purl row and forms a right-slanting decrease on the knit side. It forms a mirror image of the ssp decrease (see page 68) and looks the same as a p2tog decrease (see page 68) on the knit side.

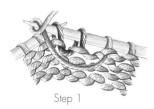

Step 1

1. Slip one stitch purlwise, then purl the next stitch.
2. Pass the slipped stitch over the purled stitch and off the right needle.

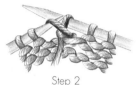

Step 2

Double Decrease (doub dec)

Double decreases are generally worked on right-side rows for a more dramatic reduction of stitches. Double decreases are usually formed by working one decrease on each side of a center axis stitch. For example, work an ssk decrease (see page 66) immediately preceding the axis stitch, knit the axis stitch, work a k2tog decrease (see page 65) immediately following the axis stitch.

This double decrease would be abbreviated "ssk, knit 1, k2tog."

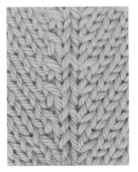

Centered Double Decrease (cent doub dec)

This double decrease creates a neat, slightly raised axis stitch. It is usually worked on knit rows.

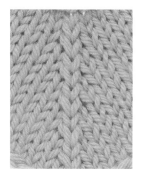

1. Insert the right needle into two stitches together knitwise and slip them to the right needle. The left stitch is the axis stitch.
2. Knit the next stitch, then use the left needle tip to pass both slipped stitches up and over the knitted stitch and off the right needle.

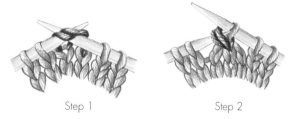

Step 1 Step 2

BIND-OFFS

Binding off secures the last row of the knitting so that it will not ravel. Binding off is also used for shaping when more than two stitches need to be eliminated at one time, such as at armholes or necklines. The bound-off edge may be the finished edge of a border, seamed, or may need overcasting, as in buttonholes. The three most common methods are described here, as well as two decorative methods.

Basic Bind-off

This is the most common and easiest bind-off method.

To bind off on a knit row, first knit two stitches, then *with the two stitches on the right needle, pass the right stitch over the left and off the end of the needle. Knit the next stitch. Repeat from * until the required number of stitches has been bound off. If you bind off all of the stitches on the needle, cut the working yarn and pull the cut end through the last stitch to secure it.

The process is the same for binding off on the purl side, with the exception that you'll purl instead of knit. For ribbing, or any other pattern stitch, bind off in pattern, that is, knit the knit stitches and purl the purl stitches, always passing the right stitch over the left and off the end of the needle.

Sloped or Bias Bind-Off

This method creates a smoothly shaped edge without the stair-step effect created by a series of basic bind-offs.

On the row preceding the bind-off row, do not work the last stitch.

1. Turn the work; there will be one stitch on the right needle. Place the working yarn in back and slip the first stitch on the left needle purlwise.

2. Pass the unworked stitch over the slipped stitch and off the end of the needle.

This will bind off one stitch. Knit the next stitch and continue binding off as for the basic bind-off method (see page 72).

> **Loose Loop Alert:** When all of the stitches on the needle are bound off, the last stitch can be quite loose. To tighten and neaten this stitch, work it with the stitch in the row below it: insert the right needle from the back into the stitch below the last stitch, lift this stitch and place it onto the left needle, then knit the stitch below and the last stitch together. Bind off the last stitch on the right needle, cut the yarn, and pull the cut end through last stitch to secure it.
>
>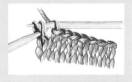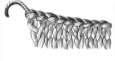

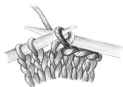
Step 1

Step 2 Finished edge

Three-Needle Bind-Off

This efficient method binds off two edges simultaneously. It produces a seam that is smooth and flat with very little bulk, and the bound-off stitches help to stabilize the seam. This technique also makes the perfect finish for short-row (see page 123) edges.

To work this bind off, there must be the same number of stitches on each piece. With the two pieces still on knitting needles, place them right-sides together with the needles parallel. *Insert a third needle, one or two sizes larger, knitwise into the first stitch on both needles and knit these together as one.* There will be one stitch on the right needle. Repeat from * to * once—there will be two stitches on the right needle. Pass the right stitch over the left and off the end of the right needle. Continue to knit together the first stitch on both left needles and pass the right stitch over the left and off the right needle until only one stitch remains on the left needle. To prevent this stitch from forming a loose bind-off loop (see page 73), knit into the stitch below the last stitch on both the front and back needles, and slip the stitches off the needles as you do so. There will be two stitches on the right needle. Pass the right stitch over the left as before, cut the yarn, and secure the last stitch by pulling the tail of yarn through it.

Wrong side

Right side

Sewn Bind-Off

The finished look of this elastic bind-off is particularly good for garter stitch.

To begin, cut the working yarn 3 times the width of the piece to be bound off and thread it on a tapestry needle.

1. Insert the tapestry needle through the first 2 stitches on the knitting needle from right to left and pull it through.

2. Insert needle back through the first stitch from left to right and pull through, slipping the stitch off the end of the needle.

Repeat Steps 1 and 2 until all stitches have been used.

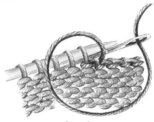

Step 1

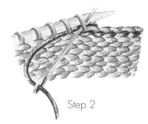

Step 2

BLOCKING

Blocking is the process of wetting or steaming the knitted pieces to even out the stitches and fibers. For best results, block the pieces before you sew them together.

> TIP: To make your own padded blocking surface, cover a piece of particle board with heavy batting or foam ¼–½" (0.5–1.5 cm) thick and then with a sturdy surface fabric such as canvas duck. Wrap the surface fabric to the back and use a staple gun to attach it to the wood.

The bands around most balls or skeins of knitting yarns give instructions for blocking. Read these instructions before you begin. In general, cotton, linen, wool, and wool-like fibers (alpaca, camel hair, cashmere) can be wet- or steam-blocked. Mohair, angora, and wool blends should only be wet-blocked, as should synthetics. Do not block Lurex or highly textured novelty yarns.

Blocking requires a flat surface larger than the largest knitted piece. Block in an out-of-the-way place on the carpet or bed. Use long straight pins, such as quilting pins, to pin the pieces to the blocking surface. First pin the length of a piece, then the width, and finally the curves and/or corners. Measure the garment at every step to ensure that the knitted piece matches the specified dimensions. Place pins every few inches to prevent the piece from contracting as it dries. If you block on a very large surface (such as the carpet), you may pin the pieces next to one another, lining up the selvedges that will be seamed to make sure that the seams will be even.

Wet Blocking

Moisten the pieces with water, pin them to the blocking surface, and allow them to air-dry. You can use a spray bottle to moisten them or, my personal favor-

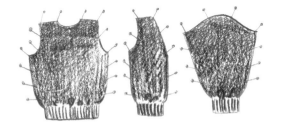

ite, roll the knitted pieces up in a large bath or beach towel that has been run through a rinse/spin cycle in a washing machine; place the roll in a plastic bag, and leave overnight. (Use two towels if the project is large.) The pieces will then be uniformly damp and ready to be pinned to the blocking surface. This method is safe for all types of yarns.

Steam Blocking

Hold an iron set on the steam setting ½" (1.5 cm) above the knitted surface and direct the steam over the entire surface, *except* the ribbing. You can get similar results by placing wet cheesecloth on top of the knitted surface and touching it lightly with a dry iron. Lift and set the iron down gently. Do not use a pushing motion. Leave the pieces pinned until they are dry.

> **TIP:** Never steam-block ribbing that you want to remain elastic, as in the waist and cuff area. Once blocked, ribbing will remain stretched out. However, you should block ribbing along a front cardigan border to flatten it and prevent it from distorting the edges of the front opening.

SEAMING

Seaming is a very important step, second only to knitting quality, in giving a professional look to a garment. Practice these methods on knitted samples until you have mastered the techniques to prevent your stunning work from being relegated to the closet, never to see the light of day.

TIP: Seams should be sewn with the same yarn that was used to knit the garment unless the yarn is unplied or nubby, in which case, sew the seams with a flat, firm yarn in a matching color.

TIP: Seams should be "pressed" as soon as they are sewn. Wet the seam on the inside of the garment using steam or a spray bottle (according to the yarn type) and gently finger-press it to reduce bulk. This also helps to "set" the seaming yarn and prevents yarn ends from working their way out.

Before you seam, block the pieces (see page 77), then pin them together as you want them to be seamed, easing in any fullness. The most common sequence of construction is to sew one or both shoulder seams, work the neckband (then sew the other shoulder seam, if necessary), sew the sleeves into the sweater body, and finish by sewing the side and sleeve seams. Take care to seam with even tension, pulling firmly, but not so tightly as to cause puckers. I like to block each seam after it is sewn by steaming or spraying it with a fine mist of water and pressing it with my fingers to reduce the bulk. After all of the seams have been sewn, turn the garment inside out and work in all loose ends of yarn.

To Begin

SEAMING WITH A CAST-ON TAIL

For the best results, use the tail from the cast-on row to start the seam.

1. Thread the tail of yarn onto a tapestry needle and, with right sides facing you, insert the needle from front to back just above the cast-on edge at the corner stitch of the piece without the tail.

2. Insert the needle from back to front into the piece with the tail, so that the yarn travels in a circle, and pull securely on the yarn to close the gap and make the bottom edge a smooth line with no indentation between pieces.

SEAMING WITH A SEPARATE LENGTH OF YARN

If there is no tail, begin the seam with a new strand, leaving a 6" (15-cm) tail to be worked in after the seam is sewn.

1. Thread the new strand onto a tapestry needle and, with right sides facing you, insert the needle from back to front on the lower corner of the left-hand piece, then from back to front in the lower corner on the right-hand piece.

2. Bring the needle into the same place on the left piece, from back to front to create a figure-eight path and a smooth bottom edge.

Right side

Invisible Weaving on Stockinette Stitch

seam (not outward toward your body) to prevent the bar from stretching and pulling to the front.

When the seam is complete, turn the work to the wrong side and work a single whipstitch (see page 97) over the seam allowance to secure the seam, then weave in the tail.

ONE-HALF STITCH SEAM ALLOWANCE

Because this method uses only a half-stitch from each edge of the seam, it produces little bulk, which allows more natural drape of the knitted fabric at the seam. Use this method for vertical seams such as sleeve and side seams. This technique works best on sportweight or thicker yarns.

Place the pieces to be seamed on a table, right sides facing up. Notice that the edge stitches of stockinette stitch alternate every row between a large, loose stitch and a smaller, tighter stitch. Beginning at the lower edge and working upward, insert a threaded tapestry needle under the bar at the base of the V-shaped tighter stitch on one side, then under a corresponding bar on the opposite side. Continue alternating from side to side, pulling the yarn in the direction of the

One-Stitch Seam Allowance

Use this method for stockinette-stitch vertical seams worked in fingering-weight yarn (sportweight and heavier yarns may produce overly bulky seams).

Place the pieces to be seamed on a table, right sides facing up. Beginning at the lower edge and working upward, insert a threaded tapestry needle under two horizontal bars between the first and second stitches in from the edge of one piece, then under two corresponding bars on the other piece. Continue alternating from side to side, pulling the yarn in the direction of the seam (not outward toward your body) to prevent the bars from stretching and pulling to the front.

When the seam is complete, turn the work to the wrong side and work a single whipstitch (see page 97) over the seam allowance to secure the seam, then weave in the tail.

Right side

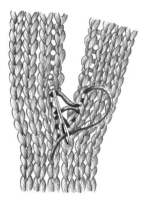

Invisible Weaving on Reverse Stockinette Stitch

Place the pieces to be seamed on a table, right sides facing up. Beginning at the lower edge and working upward, insert a threaded tapestry needle under the bottom loop of a purl bump on one piece, then under the top loop of the corresponding purl bump on the other piece. Continue alternating from side to side, pulling the yarn in the direction of the seam, causing the loops from each side to merge and form a continuous row of purl bumps.

When the seam is complete, turn the work to the wrong side and work a single whipstitch (see page 97) over the seam allowance to secure the seam, then weave in the tail.

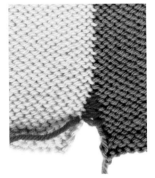

Right side

Invisible Weaving on Single (1 x 1) Rib

To maintain an uninterrupted pattern along a seam, plan your ribbing with an odd number of stitches so that the first and last stitch on all right-side rows will be a knit stitch. Then for the best finishing results, treat the rib as stockinette stitch and work a one-half-stitch seam allowance (see page 80). Two half stitches come together to form a whole knit stitch for a continuous ribbed appearance.

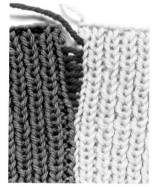

Right side

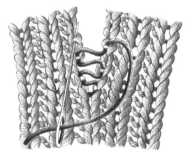

Invisible Weaving on Double (2 x 2) Rib

For an uninterrupted double rib pattern, the number of stitches in the ribbing must be a multiple of four plus two. Plan your ribbing so that the first two and last two stitches of right-side rows are knit stitches. Then treat the rib as stockinette stitch and work a one-stitch seam allowance (see page 81).

Right side

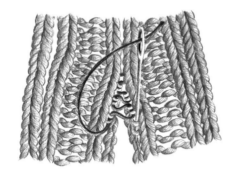

Invisible Weaving on Garter Stitch

This seam is similar to the one used for reverse stockinette stitch (see page 82).

Place the pieces to be seamed on a table, right sides facing up. Beginning at the lower edge and working upward, use a threaded tapestry needle to catch the bottom loop of the edge stitch on the knit ridge on one piece, then the top loop of the edge stitch on the knit ridge of the other piece. Continue alternating from side to side, pulling the yarn in the direction of the seam, causing the loops from each side to merge into a continuous row of ridges.

When the seam is complete, turn the work to the wrong side and work a single whipstitch (see page 97) over the seam allowance to secure the seam, then weave in the tail.

Right side

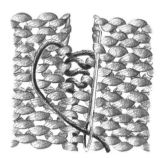

Seaming with Slip Stitch Crochet

This method is best for horizontal and curved seams such as shoulders and armholes. It will work for side and underarm sleeve seams as well, but produces more bulk in the seam allowance than you may want.

With right sides together and working one stitch at a time, insert a crochet hook through both thicknesses into the stitch just below the bound-off edge (or one stitch in from the selvedge edge). Catch the yarn and draw a loop through both thicknesses, then catch the yarn again and draw this loop through the first. This secures the end stitches together. *Insert the hook into the next stitch, through both thicknesses, then catch and draw back a loop through both thicknesses and through the loop on the crochet hook; repeat from *, keeping the crochet stitches even.

To end, cut the yarn leaving a tail 6–8" (15–20 cm) long. Pull the tail end through the last stitch on the hook. Thread the tail on a tapestry needle and weave it back through the seam allowance for 2" (5 cm).

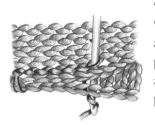

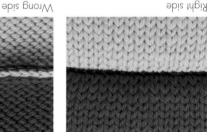

Right side

Wrong side

TIP: Slip-stitch crocheted seams are easy to remove if you've made a mistake—just pull on the working yarn to ravel. Because it's so easily removed, it's ideal for adjusting the placement of matching seams or easing in fullness.

Backstitch Seaming

This strong seam is ideal for horizontal and curved seams such as shoulder and armhole edges. It forms an elastic seam that allows for easing in fullness, as with a sleeve cap. The illustrations here show seaming the bound-off edges of shoulders.

1. Place right sides together and use a threaded tapestry needle to whipstitch (see page 97) the end stitches together. Count over two stitches and insert the needle directly under the bound-off stitches from back to front.

2. Leaving the forward stitch loose, count back one stitch and insert the needle under the bound-off stitches of both pieces from front to back, tighten the forward stitch, and pull the backstitch through the work.

3. Continue this circular motion—ahead two stitches from where the yarn emerged, then back one stitch. Pull on the seam every few stitches to prevent puckers.

To use a backstitch for armhole seams, work along the selvedge edge, moving forward ½" (1 cm) and back ¼" (0.5 cm).

Right side

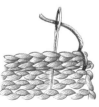

Step 1

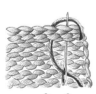

Step 2

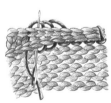

Step 3

Wrong side

Invisible Horizontal Seam

Also called "faux Kitchener," this seam joins two bound-off edges, such as shoulder seams. It is similar to grafting but is made by simply pulling the seaming yarn tight enough to cover the bound-off edges. The finished seam resembles a row of knitting. This seam requires that there be the same number of stitches on each bound-off edge.

1. Working from the right side with the bound-off edges lined up for stitch, begin by inserting a threaded tapestry needle from back to front into the V of the stitch just below the bound-off edge.

2. Insert the needle under two strands of the knit stitch on the opposite piece, then under the next two strands of the first piece.

Repeat Step 2, striving to match the tension of the knitting.

Right side

Wrong side

Invisible Vertical to Horizontal Seam

Use this method to join a bound-off edge to a selvedge edge, as in joining a sleeve to an armhole edge.

Working from the right side, begin by bringing a threaded tapestry needle from back to front in the V of a knit stitch just below the bound-off edge. Insert the needle under one or two bars between the first and second stitch in from the selvedge edge on the adjacent piece, then back into the front of the same knit stitch just under the bound-off edge. Continue working between the two pieces, striving to match the tension of the knitting, until the seam is complete. Bring the needle to the wrong side of the work and secure the yarn in the seam.

Right side

Wrong side

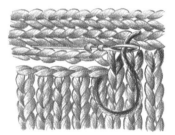

Kitchener Stitch

Lord Kitchener of Khartoum, a British military hero of Boer War and WWI, aligned himself with a Red Cross plan to dragoon U.S. womanhood into knitting "comforts" for troops in the trenches. He contributed his own sock design, featuring a squarish grafted toe, which became known as the Kitchener stitch!

Right side Wrong side

The Kitchener stitch is used to graft together stitches so that the seam looks like a continuous row of stockinette stitch. Use this method to seam the toes of socks and underarms of sweaters that have been knit in the round.

To begin, place the stitches to be grafted onto two needles and cut the working yarn, leaving a tail roughly three times the length of the seam. Thread the tail on a tapestry needle. Hold the two knitting needles together in your left hand with the needle points facing right and the wrong sides of the knitting facing together. Slide the stitches close to the needle tips and use your right hand to maneuver the tapestry needle. Use the tapestry needle to draw the working yarn through the first stitch on the front needle as if to purl and leave it on the needle. Draw the yarn through the first stitch on the back needle as if to knit and leave it on the needle. Then continue the seam as follows.

1. Draw the yarn through the first stitch on the front needle as if to knit (from front to back), and slip this stitch off the needle.

2. Draw the yarn through the second stitch on the front needle as if to purl (from back to front), but leave this stitch on the needle.

3. Draw the yarn through the first stitch on the back needle as if to purl, and slip this stitch off the needle.

4. Draw the yarn through the second stitch on the back needle as if to knit, but leave this stitch on the needle.

Repeat Steps 1–4, striving to match the tension in the knitted work.

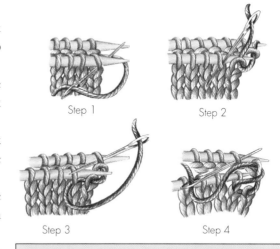

Step 1

Step 2

Step 3

Step 4

TIP: It's easy to remember how to start the Kitchener stitch if you look at the knitting: the knit side of the stockinette faces you on the front needle so your first stitch is entered knitwise, the second stitch is the opposite. On the back needle, the purl side faces you, so the first stitch is entered purlwise, the second stitch is the opposite. On both needles, the first stitch comes off, and the second stitch is left on.

Grafting for Garter Stitch

Grafting for garter stitch is similar to the Kitchener stitch (see page 91) in that the seaming yarn follows the path of the stitches, but differs in that the same movement is used for both the front and back needle. This creates the knitted ridge on the work and ensures a continuous knitted garter pattern.

The piece on the front needle must have completed a wrong-side row, so that the "bumps" are snug under the needle on the right side. The piece on the back

Right side

Wrong side

needle must have completed a right-side row, so that the smooth knit stitches are just below the needle on the right side.

Place the stitches to be grafted onto two needles and cut the working yarn, leaving a tail roughly three times the seam length. Thread the tail on a tapestry needle. Hold the two knitting needles together in your left hand with the needle points facing right and the wrong sides of the knitting facing together. Slide the stitches close to the needle tips and use your right hand to maneuver the tapestry needle.

In preparation, use the tapestry needle to draw the working yarn through the first stitch on the front needle as if to purl (from back to front) and leave this stitch on the needle. Draw the yarn through the first stitch on the back needle as if to purl and leave this stitch on the needle. Then continue the seam as follows.

1. Draw the yarn through the first stitch on the front needle as if to knit (from front to back), pull the yarn all the way through, and slip this stitch off the needle.

2. Draw the yarn through the second stitch on the front needle as if to purl (from back to front), but leave this stitch on the needle.

3. Draw the yarn through the first stitch on the back needle as if to knit, and slip this stitch off the needle.

4. Draw the yarn through the second stitch on the back needle as if to purl, but leave this stitch on the needle.

Repeat Steps 1–4, striving to match the tension in the knitted work.

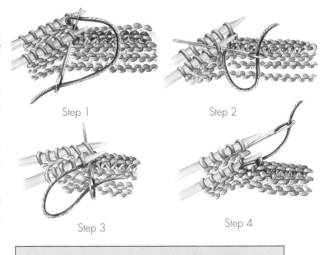

Step 1

Step 2

Step 3

Step 4

TIP: On both needles the first stitch comes off, the second is left on. On both needles, the first stitch is entered knitwise, the second stitch purlwise. To do this in a single step, take the first stitch off onto the tapestry needle, enter the next stitch, then pull the yarn through.

HEMS AND HEMMING

Hems are worked along the edges of garments that are designed to hang loosely from the body. A hem gives a neat finish and adds strength and firmness. To give a hem a crisp edge, you'll want to work a turning row at the fold line. Work to the desired depth of the hem facing, work one of the following turning rows to create a ridge to define the fold line, then work the body of the garment. When the garment is complete, sew the hem in place (see pages 96–98).

Turning Row

SIMPLE TURNING RIDGE

This method produces a clean, sharp edge.

1. Knit one wrong-side row to create a purl ridge on the right side of the work.

2. When the knitting is complete, fold the hem along the purl ridge and sew in place (see page 97).

Step 1

Step 2

Picot edge

A picot forms a decorative and flexible turning row. The turning ridge must be worked over an even number of stitches.

1. Make a turning ridge by working a right-side row as knit 1, *yarnover, knit 2 together; repeat from * to the last stitch, end with knit l. The combination of yarnovers and decreases will form a line of holes in the knitting.

2. When the knitting is complete, fold the hem along the turning ridge and sew in place (see page 97).

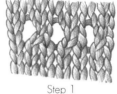

Step 1

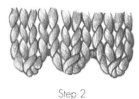

Step 2

Hem Stitches

There are several ways to sew a knitted hem in place. The most important consideration is that the stitching is not visible on the right side of the garment. For all methods, fold the hem to the wrong side along the turning ridge, and pin it in place.

BACKSTITCH

The elastic quality of a backstitch is well suited for hemmed ribbings, such as neckbands or cuffs. It is worked on stitches that are exposed from a provisional cast-on (see page 48), and binds off the hem or band stitches at the same time that it secures it in place.

1. Remove the contrasting waste yarn to expose open loops of a few cast-on stitches at a time.

2. Insert a threaded tapestry needle through an exposed cast-on loop, catch a stitch on the knitted body, then through a loop two stitches to the left.

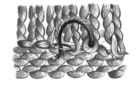

Right side

Wrong side

3. Pull the yarn snug, count back one loop, and repeat Step 2.
 Repeat Steps 2 and 3, exposing more cast-on loops as necessary.

Whipstitch or Overcast Stitch

This basic stitch does not require advance preparation (as the backstitch hem, page 96) and makes a sturdy seam. It works equally well to secure cast-on, bind-off, or selvedge edges.

*Insert a threaded tapestry needle into a stitch on the wrong side of the knitting, then into the cast-on edge of the hem. Repeat from *, moving from right to left and working stitch by stitch.

Right side

Wrong side

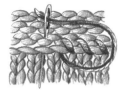

KNIT-IN HEM

This type of hem requires no sewing. It may be used with a regular cast-on as well as an invisible or open cast-on. Work the hem and turning ridge of your choice, then continue with the body of the piece until it is the same depth as the hem, ending with a wrong-side row.

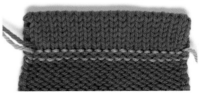

Right side

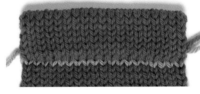

Wrong side

For a regular cast-on

1. Using a smaller knitting needle than used to knit with, insert the needle into the front half of each cast-on stitch.
2. Fold up the hem so that wrong sides are together and the needles are held parallel to each other with the stitches for the main body held in front, then knit one stitch from the front needle together with one stitch from the back needle.

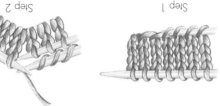

Step 1 Step 2

For a provisional cast-on

1. Remove the waste yarn from the cast-on and place each open loop on an extra needle.
2. Work as for Step 2 of regular cast-on.

BORDERS AND EDGES

Borders and edges give garments stability and prevent the knitted pieces from curling. They need to be worked in stitch patterns that lie flat, such as ribbing, garter, or seed stitch. In choosing a border, consider the finished look you desire. In general, smoother borders produce dressy looks; textured borders tend to give a casual look.

> TIP: Picked-up stitches can cause holes to form in the garment, especially along curved edges. Watch out for these and if you see one, take out that stitch and pick it up elsewhere or twist the edge loop before pulling the working yarn through to eliminate the hole.

> TIP: Pick up stitches with a needle one or two size(s) smaller than you used to knit the body of the garment (generally the size used for the ribbing).

Picking Up Stitches

Stitches are picked up to create finished neckbands, cardigan borders, and pocket edges, and to work sleeves downward from the shoulders to the cuffs. Stitches are almost always picked up from the right side using a separate ball of yarn.

Beginning at the right corner of the knitted edge and working from right to left, insert the needle under two strands of the selvedge or edge stitch, wrap the needle as if to knit, and pull the loop through to right side to create a stitch on the needle.

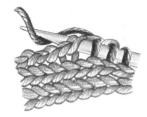

PICK UP STITCHES EVENLY SPACED

To make sure that the stitches picked up are spaced evenly, divide the knitted edge into fourths (or eighths for a very long edge) and mark these divisions with open markers. Then pick up one fourth (or eighth) of the desired total number of stitches in each section. (*Note:* The halfway point on a crew neckline that is open at one shoulder will not be at the shoulder seam.)

If you plan to use a pattern stitch that has been used elsewhere in the garment, simply measure the gauge in that area (measure ribbing slightly stretched). If you plan to use a new pattern, you will need to work a new 4" (10-cm) gauge sample (see page 35). To compute the number of stitches to pick up, divide the length of the edge to be picked up by 4 and multiply this number by the number of stitches in your 4" (10-cm) gauge.

Round up or down as needed, remembering that a single rib requires an odd number of stitches and double rib requires a multiple of 4 plus 2 stitches when worked flat. (If you are knitting in the round, a single rib requires an even number of stitches; a double rib requires a multiple of four stitches.) Stockinette stitch can have any number of stitches.

TIP: Most patterns will tell you to "pick up and knit" a specific number of stitches. Read literally, this is somewhat misleading—you should not pick up a stitch and then knit it. You should pick up a stitch as if to knit it and leave it on the needle. When all stitches are on the needle, turn the work, and purl the next row for the neatest transition possible. With right side facing you again, begin the stitch pattern you plan to work for the border (or sleeves).

Single (1 x 1) Rib

Single rib is worked by alternating one knit stitch with one purl stitch across a row. On subsequent rows, knit the stitches that appear as knit stitches and purl the stitches that appear as purl stitches. If you're working with an even number of stitches, each row will begin with a knit stitch. If you're working with an odd number of stitches, right-side rows will begin and end with a knit stitch; wrong-side rows begin and end with a purl stitch.

Double (2 x 2) Rib

Double rib is worked by alternating two knit stitches with two purl stitches. It is worked on a multiple of 4 stitches, but if you want the rib to begin and end with "knit 2," use a multiple of 4 stitches plus 2 stitches (for example, use 14 stitches instead of 12). Right-side rows will begin and end with knit 2; wrong-side rows will begin and end with purl 2.

Garter Stitch

Garter stitch can be worked on any number of stitches. Simply knit every stitch of every row.

Seed Stitch

Seed stitch is worked by alternating one knit stitch with one purl stitch across one row, then offsetting the knits and purls on subsequent rows (knit the stitches that appear as purl stitches and purl the stitches that appear as knit stitches). If you're working with an odd number of stitches, begin each row with a knit stitch. If you're working with an even number of stitches, begin right-side rows with a knit stitch; begin wrong-side rows with a purl stitch.

Crocheted Edges

Crocheted edges are usually narrower than knitted ones and produce stable, clean finishes. Single crochet makes a smooth finish; reverse single crochet makes a decorative beadlike finish. Half double crochet and double crochet make more visible statements. For all crochet stitches, insert the hook into the knitted work under both strands of the edge stitches, whether working along a selvedge or a bound-off edge. Cut the yarn and secure the last loop by pulling the yarn tail through it.

TIP: Work three crochet stitches into the same spot at each corner for a clean, flat turn.

SINGLE CROCHET

Work this stitch from right to left. To begin, insert the hook into a knitted edge stitch, draw up a loop, bring the yarn over the hook, and draw this loop through the first one.

1. Insert the hook into the next stitch to the left and draw up a loop.
2. Bring the yarn over the hook again and draw this loop through both loops on the hook

Repeat Steps 1 and 2 for the desired length.

REVERSE SINGLE CROCHET (SHRIMP STITCH OR CRAB STITCH)

Work this stitch from left to right. To begin, insert the hook into a knitted edge stitch, draw up a loop, bring the yarn over the hook, and draw this loop through the first one.

1. Insert the hook into the next stitch to the right and draw up a loop.
2. Bring the yarn over the hook again and draw this loop through both loops on the hook.

Repeat Steps 1 and 2 for the desired length.

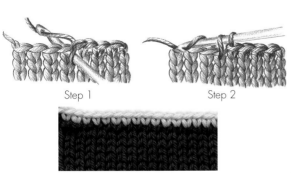

Step 1 Step 2

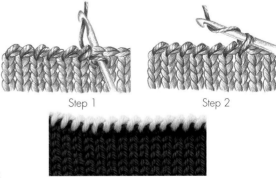

Step 1 Step 2

HALF-DOUBLE CROCHET

Work this stitch from right to left. To begin, insert the hook into a knitted edge stitch, draw up a loop, bring the yarn over the hook, and draw this loop through the first one.

1. Working from right to left, yarn over the hook.
2. Insert the hook into the next knit stitch to the left and draw up a loop, yarn over the hook and draw this through all 3 loops on hook

Repeat Steps 1 and 2 for the desired length.

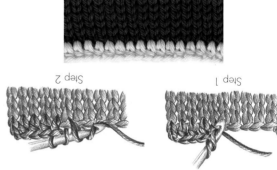

Step 1 Step 2

DOUBLE CROCHET

Work this stitch from right to left. To begin, insert the hook into a knitted edge stitch, draw up a loop, bring the yarn over the hook, and draw this loop through the first one.

1. Working from right to left, yarn over the hook.
2. Insert the hook into the next knit stitch to the left, draw up a loop, yarn over the hook and draw it through the first 2 loops on hook.
3. Yarn over the hook again and draw through the remaining 2 loops on hook.

Repeat Steps 1–3 for the desired length.

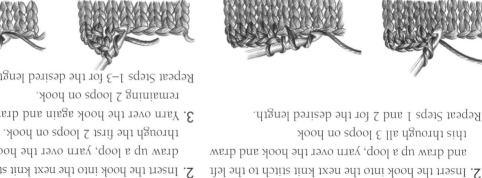

Step 1 Step 2 Step 3

DETAILS

Details can make the difference in any knitting project. From a well-trimmed buttonhole to flowy fringe to flashy beads, a few well-placed details can transform a project from ordinary to extraordinary.

Beads

The easiest way to add beads to your knitting is to use a crochet hook to slip a bead over a live stitch, then knit that stitch. Be sure that the bead you use has a hole large enough to accommodate both the yarn and a small crochet hook. You can use this method to add beads whenever you wish.

Place a bead on the hook. Slip the stitch from the knitting needle onto the hook and pull the stitch through the bead. Replace the stitch onto the left needle and knit it.

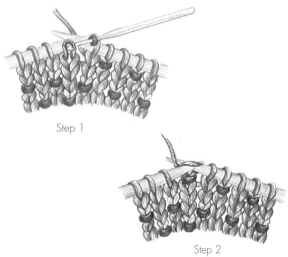

Step 1

Step 2

Buttonholes

EYELET BUTTONHOLE

The eyelet buttonhole is self-sizing—bulky yarns make large holes that accommodate large buttons; fine yarns make small holes that accommodate small buttons. This buttonhole is virtually hidden in a border of single rib. Work the eyelet buttonhole on the right side as follows: yarnover, then work the next two stitches together. That's all there is to it.

Stockinette stitch

Single rib

REINFORCING BUTTONHOLES

Depending on the flexibility of the yarn and the stitch you've used, you may want to overcast the buttonhole or reinforce it with a buttonhole stitch.

Eyelet buttonhole reinforced with overcast stitch.

Eyelet buttonhole reinforced with buttonhole stitch.

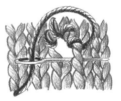

Overcast stitch

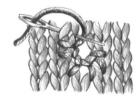

Buttonhole stitch

ONE-ROW BUTTONHOLE

This visible horizontal buttonhole is neat and firm and requires no reinforcing. The lower edge of the button-hole is worked from the right side of the garment; the upper edge is worked from the wrong side.

TIP: You can make a one-row buttonhole any size — simply use the cable method to cast on one more stitch than was decreased, knowing that the extra stitch is used to close the hole.

TIP: You can improve on this method if in Step 2 you use the knitted method (see page 47), inserting the needle into the first stitch knitwise, to cast on the first stitch, then use the cable method (see page 46) to cast on the remaining 4 stitches. Work Step 3 as follows: With yarn in front, slip the first stitch from left to right needle, pass the extra cast-on stitch over it, pull gently on the working yarn to close the hole. Slip the stitch back onto left needle, bring the yarn to the back, pass stitch back to right needle, then work to end of row.

Work to where you want the buttonhole to be, bring the yarn to the front, slip the next stitch purlwise, then return the yarn to the back.

1. *Slip the next stitch to the right needle, then pass the second stitch over the end stitch and drop it off the needle. Repeat from * 3 more times.

2. Slip the last stitch on the right needle to the left needle and turn the work. Move the yarn to the back and use the cable method (see page 46) to cast on 5 stitches as follows: *Insert the right needle between the first and second stitches on the left needle, draw up a loop, and place it on the left needle. Repeat from * 4 more times. Turn the work.

3. With the yarn in back, slip the first stitch from the left needle and pass the extra cast-on stitch over it and off the needle to close the buttonhole, then work to the end of the row as usual.

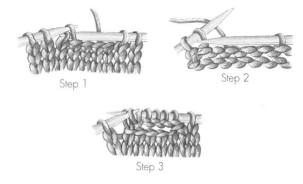

Step 1

Step 2

Step 3

Duplicate Stitch

This embroidery technique is used to cover knit stitches decoratively after a knitted piece has been blocked. Duplicate stitches are worked with a tapestry needle threaded with yarn the same weight or slightly heavier than the yarn used to knit the garment. Choose one of the countless cross-stitch and needlepoint charts to work from or get some graph paper and chart your own design.

TIP: Keep in mind that knit stitches are slightly wider than they are tall, so designs charted on square graph paper will produce a knitted image that appears compacted in height.

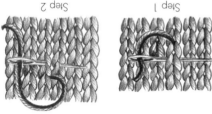

1. Bring the threaded tapestry needle up from the back at the base of the V of the knit stitch to be covered, then insert it under both loops of the stitch in the row above it, and pull the needle through.

2. Insert the needle into the base of the V again, and pull the needle through to the back of the work.

Step 1 Step 2

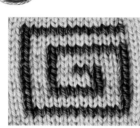

French Knot

Bring a threaded tapestry needle through the work from wrong side to right side, wrap the yarn around the needle three times, then insert needle a short distance (shown by x on illustration) from where it came out, using your thumb to hold the wraps in place while pulling the needle through them to the wrong side.

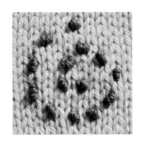

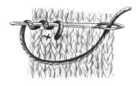

Fringe

TRADITIONAL FRINGE

1. For each fringe cut one or more strands, each slightly longer than two times the desired finished length.
2. Fold the strand(s) in half and use a crochet hook to pull the fold through the knitted edge from front to back for an inch or so. It does not matter whether you pull the yarn through from back to front or vice versa, but be consistent with which direction you choose.
3. Pull the cut ends through the fold and pull on them gently to coax the fold close to the edge.

KNOTTED FRINGE

1. For each fringe, cut one or more strands, each slightly longer than two times the desired finished length.
2. Use a crochet hook to pull the strand(s) halfway through the knitted work.
3. Fold the strands in half so that the cut ends are aligned, tie all of the strands into an overhand knot, and use a tapestry needle to coax the knot into position against the edge of the work.

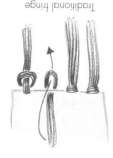

Traditional fringe

Knotted fringe

Knitted Cord

Knitted cord is a great way to create a tube. It is worked with double-pointed needles in such a way that the right side is always facing you.

1. With double-pointed needles, cast on three stitches. Do not turn the work.
2. With right side still facing, slid the stitches to the right needle tip.

3. Bring the yarn across the back of the stitches to the tip of the needle, and knit the three stitches again.

Repeat Steps 2 and 3 until the cord is the desired length. To finish, leave the stitches at the left needle tip and pass the second and third stitches over the first stitch and off the end of the needle. Cut the yarn and pull the tail end through the last loop to secure.

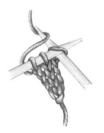

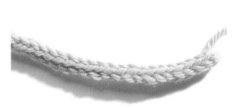

Pom-Pom

Whimsical and cheery, pom-poms are a great way to embellish anything you knit, from edges of jackets to centers of pillows to tops of hats. All you need is yarn and something stiff to wrap the yarn around, like a piece of cardboard or a book the desired size.

1. Wrap yarn around a stiff form the desired number of times (the more wraps, the fuller the pom-pom).

2. Cut two strands of yarn, each about 18" (45.5 cm) long and lay them on a flat surface. Slide the pom-pom wraps off the cardboard and lay them perpendicularly over the two strands; tie the strands in a square knot around your pom-pom wraps.

3. Cut the loops, shake out pom-pom, and trim to an even, round shape. Use the ends of the strands to attach the pom-pom to whatever you want.

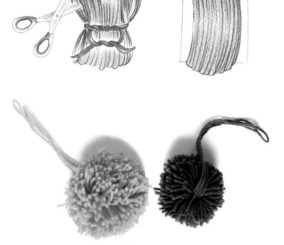

Step 1

Step 2

TIP: Wrap yarn twice in the first step of the square knot so it will hold better while you work the second step of the knot.

Tassel

1. Wrap yarn around a stiff form the desired number of time (the more wraps, the fuller the tassel). Use scissors to cut one end of the wraps.
2. Cut two strands of yarn, each about 18" (45.5 cm) long and lay them on a flat surface. Place the tassel wraps perpendicularly over the two strands, then tie the strands in a double knot.
3. Cut a piece of yarn about 36" (91.5 cm) long. Lay one cut end of the yarn parallel to the tassel strands, fold the cut yarn back on itself to create a loop beyond where you want the wrap to end, and beginning at the cut end, wrap the yarn snugly around the tassel, placing the wraps close to each other to completely cover the tassel strands.
4. When the desired length of wrap is reached, pull the second cut end through the foundation loop until it lies smoothly, and pull downward on the first cut end to hide the foundation loop in the center of the wrap. Trim ends even with wrap.
5. Trim the ends of the tassel.

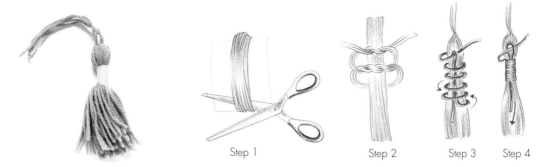

Step 1 Step 2 Step 3 Step 4

South American Knitted Join

This technique allows you to knit stripes in the round with smooth transitions at the color changes.

1. Slip the last stitch of the round knitwise.

2. Use the right needle tip to lift the stitch in the row below the first stitch on the left needle (this is the first stitch in the previous round), place it on the left needle, then slip it to the right needle.

3. Work these two stitches together as an ssk decrease (see page 66), then continue knitting with the new color for the desired number of rounds. Repeat Steps 1–3 for each color change.

Step 1

Step 2

Step 3

OTHER TECHNIQUES

Cables

Cables are simple and fun to do and give your knitting a rich, textural quality. A cable (or cross) is made by working a group of stitches out of order. A cable needle (a short, double-pointed needle) is used to temporarily hold stitches out of the way while knitting the next ones, thus reversing their order and crossing them over one another. Hold the crossing stitches in front of the work for a left-crossing cable; hold them in back for a right-crossing cable. Four-, six-, and eight-stitch cables are the most common simple cables, but any number of stitches may be crossed. In the sample shown on page 118, a six-stitch right cable is worked between purl stitches to make the cable more prominent visually. The more stitches you cross, the tighter the stitches will feel, but they will relax after the next row is worked. Usually, cable stitches are knitted on right-side rows and purled on wrong-side rows. Vertical columns of stockinette stitch and reverse stockinette stitch form the foundation for cables, which are crossed at regular intervals.

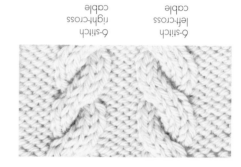

6-stitch
left-cross
cable

6-stitch
right-cross
cable

1. Work to the first of the cable stitches (6 stitches in this example).
2. Slip 3 stitches onto a cable needle and hold them in back of the work for a right-twist cable.
3. Knit the next 3 stitches on the knitting needle, then knit the 3 stitches from the cable needle.

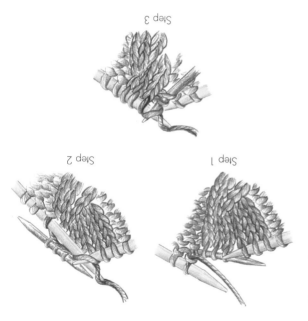

Step 1

Step 2

Step 3

Color Knitting

Knitting with two or more colors of yarn produces exciting effects. Volumes have been written about color knitting. What's given here are the bare bones for those who want an introduction or refresher.

Fair Isle

Fair Isle, or color stranding, is the technique of multi-colored knitting in which yarns that are not in use are carried loosely across the back of the work. In traditional Fair Isle, just two colors are used per row, the colors are changed frequently, and diagonal pattern lines dominate over vertical lines to distribute the tension more evenly over the knitted fabric.

Fair Isle is worked most efficiently if the two yarns are held simultaneously; one in the left hand and worked in the Continental method (see pages 29–30), the other in the right hand and worked in the English method (see pages 31–32). Although this may feel awkward at first, it is well worth the effort because it allows for uniform stitches and rapid knitting.

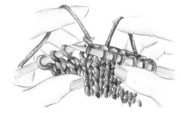

Prevent tangles You can prevent the two balls of yarn from tangling around each other as you knit by always stranding the right-hand yarn over the left-hand yarn and the left-hand yarn under the right-hand yarn. Do not twist the strands on the back.

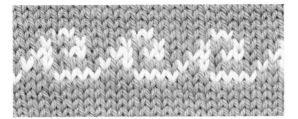

Prevent puckers In multicolor knitting, the stitches will pucker if the strands are pulled too tightly across the back. To prevent this, spread the stitches on the right-hand needle to their approximate gauge each time you change colors, rather than allowing them to scrunch up near the tip of the needle.

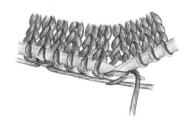

Secure the floats Once in a while, a strand will float so long across the back of the work that it needs to be secured to prevent snagging. Lift up the strand to be woven, then knit the next stitch wrapping the working yarn underneath the strand, then knit the next stitch with the woven strand and knit the next stitch with the working yarn above the strand. Continue to alternate lifting and lowering the strand, catching it in between the working yarn and the new stitch, and securing it on the back of the work.

Two-handed knitting In color knitting, you can keep track of the two yarns by always holding the pattern color in your right hand (as for the English method) and always holding the background color in your left (as for the Continental method). Use the English method to pass the yarn around the needle with your right hand, so that the working yarn passes over the background yarn on the back. Use the Continental method to pick the yarn held with your left hand, so that the working yarn passes under the pattern yarn on the back. If you work back and forth in rows, requiring that you knit as you purl, follow the same convention—pattern yarn strands over; background yarn strands under.

INTARSIA

Intarsia, or jacquard, is a method used to knit isolated blocks of color. These blocks may have vertical, horizontal, diagonal, or curved boundaries. Because the colors are used in limited areas, this type of knitting must be worked back and forth (knit one row, purl one row), not circularly. A separate "ball" of yarn is used for each color block. A little guess work is needed here—you'll have to estimate the amount of yarn that each block will require. For the technically adventurous, count the number of stitches in a block of color and then wind the yarn around the knitting needle that number of times to get a close estimate of yarn needed. When working intarsia, visualize vertical segments of color to help you plan for strands or balls to work from. For example, the heart motif shown here required one strand of purple to work the background on the right side of the heart, one strand of the contrasting color to work the heart, and a second strand of the purple to work the background on the left side of the heart.

Manage the separate yarns You can work from several balls of yarn, allowing the balls to hang from the back of the knitting, or you can wind separate

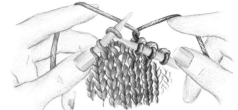

lengths of yarn onto bobbins (a separate bobbin for each block of color). Tangles are inevitable, whether you use strands or bobbins, but you may find it easier to pull single unwound strands that are less than three arms' lengths long through a tangle than to untangle bobbins.

Prevent holes at color changes Where the working yarns change, twist the yarns around one another to prevent holes in the knitting. In general, pick up the new color from *beneath* the color that you had been working with. To change colors along a vertical line, twist the yarns around one another on every row. To change colors along a diagonal line, twist the yarns around one another on every other row. If the diagonal is right-slanting, twist the yarns only on the knit rows; if the diagonal is left-slanting, twist the yarns only on the purl rows. When working a right-slanting diagonal on the knit side, twist the yarns by bringing the new color over the top of the old one. On the

following purl row, simply pick up the new color from under the old. When working a left-slanting diagonal on the purl side, twist the yarns by bringing the new color over the top of the old one.

COMBINED TECHNIQUES

Sometimes a combination of intarsia and Fair Isle may be worked, as when there are only a couple of stitches to be worked in a nearby color. If the color does not have to strand across too many stitches, you may want to combine techniques. I used the Fair Isle technique to work the three stitches of background at the center top dip of the heart shown in the photo on page 121.

Short-Rows

Short-rows are used to work partial rows, thereby increasing the number of rows in one area without having to bind off stitches in another; the number of stitches remains constant. This type of shaping eliminates the stair-step edges that occur when a series of stitches are bound off, as is commonly used to shape shoulders and necks.

When working short-rows, you'll work across part of a row, wrap the yarn around a turning stitch, turn the work, work back across some of the stitches you just worked, turn, etc., until the desired number of extra rows has been worked. To prevent holes at the turning points, the slipped turning stitches are wrapped with the working yarn. After working the short-rows, all of the stitches can be bound off at once, or they can be joined directly to another piece with the three-needle bind-off (see page 74), for a neat, flat, stable seam.

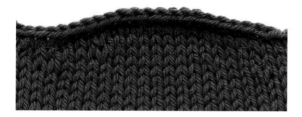

TURNING ON A KNIT ROW

1. With the yarn in back, slip the next stitch purlwise.
2. Pass the yarn between the needles to the front of the work.
3. Slip the same stitch back to the left needle and pass the yarn between the needles to the back of the work.
4. Turn the work and continue to work another row on the stitches just worked.

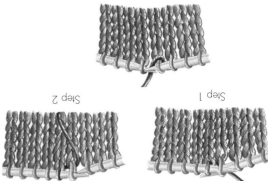

Step 1 Step 2 Step 3

TURNING ON A PURL ROW

1. With the yarn in front, slip the next stitch purlwise.
2. Pass the yarn between needles to the back of the work.
3. Slip the same stitch back to the left needle and pass the yarn back between the needles to the front of the work.
4. Turn the work and continue to work another row on the stitches just worked.

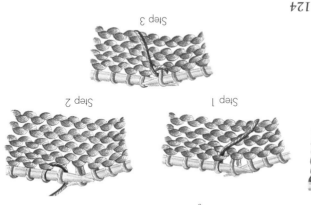

Step 1 Step 2 Step 3

Hiding Wraps

On the return rows, hide the wraps by working them together with the stitches that have been wrapped.

Knit rows Work to just before the wrapped stitch, insert the right needle under the wrap and knitwise into the wrapped stitch, then knit them together as if they were a single stitch.

Knit the wrap together with the wrapped stitch.

Purl rows Work to just before the wrapped stitch, insert the right needle from behind into the back loop of the wrap, place the wrap on the left needle, and purl it together with the wrapped stitch on the left needle.

Purl the wrap together with the wrapped stitch.

Knitting in the Round

Knitting in the round is simply knitting around and around without turning the work, creating a tube of knitted fabric. This technique has the advantage of having no seams, and the right side of the knitting always faces the knitter (i.e., there are no purl rows).

USING CIRCULAR NEEDLES

Circular needles are two short needles, each 5 or 6" (12.5 or 15 cm) long, connected by a cable. Circular needles come in various lengths and allow the the weight of the knitting to rest on the connecting cable so there is no stress on the knitter's wrists. You can knit in rows or in rounds with circular needles. When knitting in the round, there must be enough stitches to accommodate the length of the cable.

USING DOUBLE-POINTED NEEDLES

Double-pointed needles have points at both ends, come in sets of four or five, and in lengths of seven or ten inches. They allow you to knit smaller circumference pieces such as socks, mittens, sleeve cuffs, and

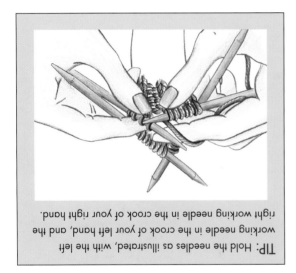

TIP: Hold the needles as illustrated, with the left working needle in the crook of your left hand, and the right working needle in the crook of your right hand.

neckbands circularly. The stitches are evenly divided between three needles, forming a triangle, and the fourth is used to knit (or the stitches are divided between four needles, forming a square, and the fifth is used to knit). Cast on the required number of stitches on one needle, then divide the stitches evenly onto the others. Take care to avoid twisting the cast-on edge when the knitting is joined.

To join, lay the three needles in a triangle (or four needles in a square) on a flat surface. Arrange the cast-on edge so that it faces the inside of the triangle (or square). Keeping the needles in this arrangement, pick them up and use the fourth (or fifth) needle to begin knitting by inserting it into the very first cast-on stitch and wrapping the needle with the working yarn that emerges from the last cast-on stitch.

Knitting Backward

This useful technique allows you to work stockinette stitch with the right side of the work always facing you. It is especially handy when you're working on just a few stitches, as in making a bobble.

1. Insert the left needle into the back of the first stitch on the right needle and wrap the working yarn counterclockwise around the left needle.

2. Pull the new stitch on the left needle through to the front of the work and let the old stitch slip off the right needle.

Repeat Steps 1–2.

Step 1

Step 2

TIP: To prevent loose stitches from forming at the boundaries between needles when changing needles, bring the empty needle up from the bottom into the next stitch so that it sits snugly against the needle just finished. Wrap the working yarn with some tension but not so tightly that the yarn is stretched and the loft destroyed. When purling, bring the needle over the needle just finished into the next stitch and wrap the working yarn with some tension.

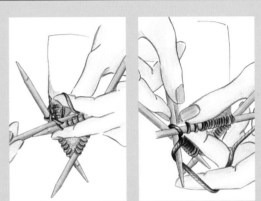

Correcting Errors

If you can recognize what knit and purl stitches look like as they sit correctly on the needles, you'll find that correcting errors is relatively simple. A correct knit or purl stitch forms an upside-down U over the needle. The right leg of the stitch falls in front of the needle (and is aptly called the "leading" leg); the left leg falls behind the needle.

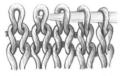

Correct orientation of knit stitches.

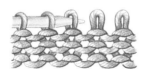

Correct orientation of purl stitches.

TWISTED STITCHES

A twisted or backward stitch will have the leading leg in back of the needle.

1. Insert the other needle through the back loop of the twisted stitch to turn it around.
2. Place the stitch on the needle with the leading leg in the front.

Twisted stitch

Insert right needle through back of sittch to correct its orientation.

DROPPED STITCHES

With the help of a crochet hook, you'll find it easy to pick up any stitch that drops.

Knit Rows

1. Insert the hook, from front to back, into the loop of the dropped stitch.
2. Use the hook to catch the first horizontal "ladder" in the knitting and pull it through the loop to the front.

Repeat Steps 1 and 2 until all of the ladders have been used. Place the last loop on the needle, making sure that the leading leg is in front of the needle.

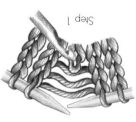

Step 1

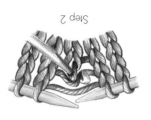

Step 2

Purl Rows

If a stitch drops and ravels on a purl row, you can simply turn the work around and correct as for the knit side, making sure to turn the work back around to finish the purl row. Or, you can pick up the dropped stitch from the purl side.

1. Insert the crochet hook, back to front, into the loop of the dropped stitch, placing the first horizontal "ladder" in front of the stitch.
2. Pull the ladder through the loop to the back.

Repeat Steps 1 and 2 until all of the ladders have been used. Place the last loop on the needle, making sure that the leading leg is in front of the needle.

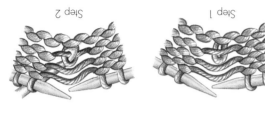

Step 1

Step 2

Edge Stitch When an edge stitch drops and ravels, there will be no visible "ladders," but there will be a large loop extending from the edge above a small loop, below which the knitted edge is intact.

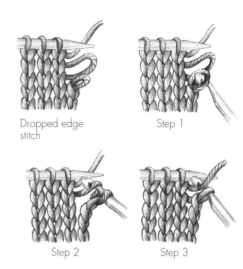

Dropped edge stitch

Step 1

Step 2

Step 3

1. Insert the crochet hook into the small loop, from front to back, then hold the large loop with some tension as you pull the lower part of the large loop through the loop on the hook to form a stitch.
2. With the hook in the stitch just made, pull the upper part of the large loop through this loop to form another stitch.

Repeat Steps 1 and 2 as many times as necessary.

3. With the hook in the last stitch made, pull the working yarn through this loop.
4. Place the last stitch on the needle, making sure that the leading leg is in front of the needle.

INCOMPLETE STITCHES

An incomplete stitch is a stitch from the previous row that is on the needle and the unworked strand of yarn either lies in a horizontal path across the back or is looped over the needle.

The unworked strand is in a horizontal path across the back

1. Use a crochet hook to pull the unworked strand through the stitch of the previous row, from the front for a knit stitch and from the back for a purl stitch.
2. Place the corrected loop on the needle so that the leading leg is in front of the needle.

Unworked strand travels across back of work.

The unworked strand is looped over the needle

1. Insert the right needle into the stitch of the previous row.
2. Pass the stitch over the unworked strand.
3. Place the corrected loop on the needle so that the leading leg is in front of the needle.

Unworked strand is looped over the needle.

Taking Out Stitches

If you need to take stitches that have already been worked, simply "unknit" the stitches. In knitterese, this is called "frogging" because you "rip it."

Take out up to one row of stitches

1. Insert the left knitting needle into the front of the stitch in the row below the first stitch on the right needle for either a knit or purl stitch.

2. Keeping the left needle in the stitch in the row below, pull on the working yarn as you ease the stitch off of the right needle and let it drop.

Take out two or more entire rows of stitches.

1. Remove the needles from the stitches and pull on the working yarn to ravel the stitches to one row above the desired point.

2. To prevent unwanted dropped stitches, pull out the last row, stitch by stitch, placing the open loops on a needle as you go.

TIP: When taking out stitches, use a needle that is smaller than the one used to knit with to facilitate picking up the loops. But be sure to resume knitting with the correct needle.

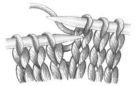
Take out a knit stitch.

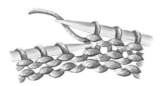
Take out a purl stitch.

Caring for Handknits

After you have spent countless hours knitting and finishing a garment, you should not be casual about its care. You can extend the life of a garment indefinitely by practicing good washing and storage techniques.

WASHING

Before washing, test the yarn for colorfastness by dipping a corner of the garment in warm soapy water, then gently pressing out the liquid onto a clean white cloth. If any color stains the cloth, wash the garment in cold water; otherwise, use warm water. Colors that bleed badly can be "set" with a rinse of one-quarter cup vinegar to one gallon water, prior to each washing. Do not leave garments to soak for long periods, particularly if they have intense colors or are multi-colored, as this increases the risk of color bleeding.

1. Fill a basin with warm water of the appropriate temperature, add pure soap flakes or wool detergent, and use your hands to work up lather.
2. Place the garment in the basin and gently squeeze the suds into it. Avoid rubbing the knitted fabric, or it may become felted.

RINSING

1. Gather the garment into a ball and remove it from the basin, drain the water, and fill the basin again with clear rinse water of the same temperature used for washing.
2. Return the garment to the basin and gently squeeze it in the water to remove the suds. Repeat Steps 1 and 2 until the rinse water is clear.

DRYING

1. Use your hands to press as much water out of the garment as possible, roll it up in a thick towel, and again press out as much water as possible. Repeat this with a second towel if necessary. Be careful not to twist or wring the garment at any time.

2. Arrange the damp (but not dripping) garment to the shape you desire (see Blocking, page 76) on a sweater drying rack or a flat surface covered with a dry towel, away from direct sun or heat.

Leave the garment to thoroughly air-dry.

STORING

Store garments flat—placing them on hangers will cause the knitted fabric to sag and distort the shape.

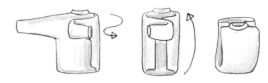

INDEX